CAPTURING
RADIANT
Light & Color
IN OILS AND SOFT PASTELS

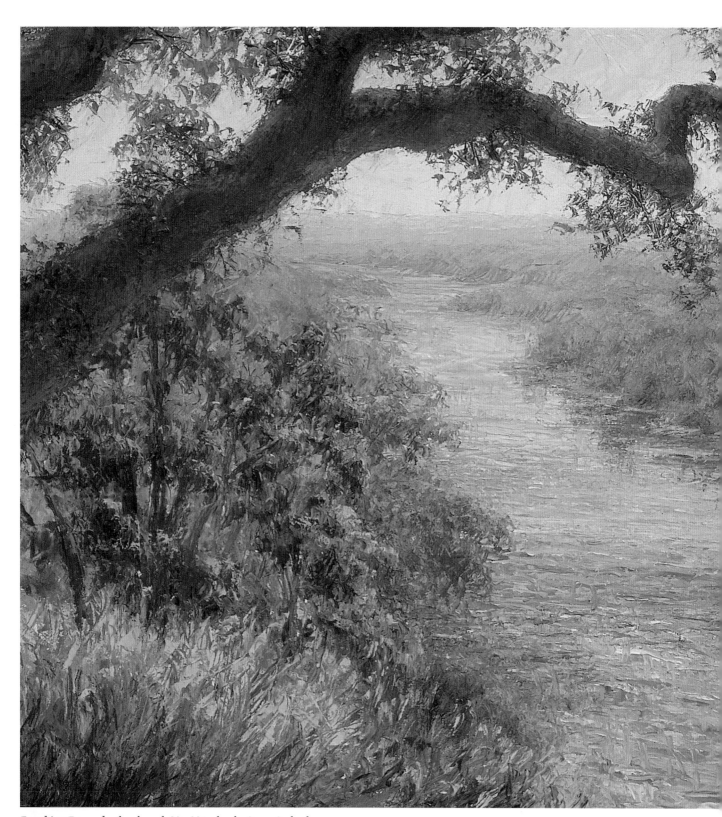

Reaching Beyond, oil on board, 20 x 30 inches by Susan Sarback.

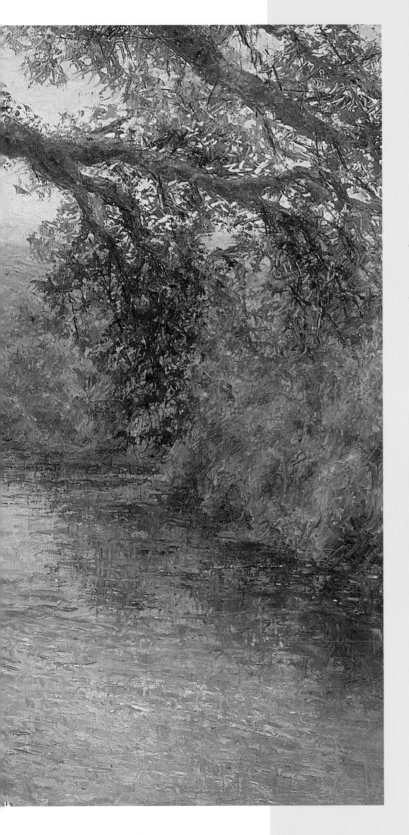

From the Founder of
The School of Light & Color

Susan Sarback

CAPTURING
RADIANT
Light
&
Color

IN OILS AND SOFT PASTELS

Learn the secrets of seeing
like the Impressionist painters
and how to apply that vision,
step by step, to your own paintings.

NORTH LIGHT BOOKS
CINCINNATI, OHIO
www.artistsnetwork.com

METRIC CONVERSION CHART

To convert	to	multiply by
Inches	Centimeters	2.54
Centimeters	Inches	0.4
Feet	Centimeters	30.5
Centimeters	Feet	0.03
Yards	Meters	0.9
Meters	Yards	1.1

Other fine North Light Books are available from your local bookstore, art supply store or direct from the publisher.

11 10 09 08 07 5 4 3 2 1

DISTRIBUTED IN CANADA BY FRASER DIRECT
100 Armstrong Avenue
Georgetown, ON, Canada L7G 5S4
Tel: (905) 877-4411

DISTRIBUTED IN THE U.K. AND EUROPE BY DAVID & CHARLES
Brunel House, Newton Abbot, Devon, TQ12 4PU, England
Tel: (+44) 1626 323200, Fax: (+44) 1626 323319
Email: postmaster@davidandcharles.co.uk

DISTRIBUTED IN AUSTRALIA BY CAPRICORN LINK
P.O. Box 704, S. Windsor NSW, 2756 Australia
Tel: (02) 4577-3555

Library of Congress Cataloging in Publication Data
Sarback, Susan
 Capturing radiant light and color in oil and soft pastels / by Susan Sarback.
 p. cm.
 Includes index.
 ISBN-13: 978-1-58180-999-2 (pbk. : alk. paper)
 ISBN-10: 1-58180-999-9 (pbk. : alk. paper)
 1. Light in art. 2. Color in Art. 3. Painting--Technique. I. Title.
 ND1484.S27 2007
 752--dc22 2006029216

Edited by Kathleen Fenton
Designed by Lydia Inglett Spears
Production coordinated by Matt Wagner

Dedication

This book is dedicated to all of my students who have taught me how to clearly teach this enlightening subject.

Acknowledgments

I would like to thank the following people:

Lydia Spears, my graphic artist, who both inspired me to begin this effort and whose expertise in design is evident throughout the book. Her genuine kindness and patience made our work together a delight.

Kathleen Fenton, a pastel artist who has greatly helped with the editing and compiling of this book. Her clear thinking, organizational ability, and genuine love for this subject shows in the detail and flow of this work.

Tim Bellows, an editor with the heart of a poet whose thorough command of the language and attention to detail lent refinement to this text.

Mary Carroll Moore, a pastel artist and an accomplished author in her own right, compiled and organized information for this book that helps to tie it all together.

Paula Jones, my writing collaborator for the first edition of this book that laid the foundation for this revised and expanded edition.

Patrick O'Kane, of Cali-Color, for photographing the paintings and preparing the digital images presented in this book. Pat is a master of his craft, patient and committed to quality. These traits and his accommodating nature make him exceptionally easy to work with.

The instructors at my School of Light and Color, accomplished artists in their own right, whose work and contributions to this book reflect their dedication to the art of painting and teaching this wonderful subject:

Rhonda Egan, oil painter, Irene Lester, pastel artist, Paula Cameto, oil painter, Marilyn Rose, oil painter, and Marianne Post, pastel artist.

Jamie Markle of North Light Books, for his consideration and support in bringing this book to publication.

I must acknowledge my gratitude to Henry Hensche for teaching me how to see and paint the radiant light and color that constantly surrounds us.

– S.S.

"The purpose of art is to lift the veil of mystery into consciousness."

– HENRY HENSCHE

About the Author

Susan Sarback, a native of New York City, was surrounded by great art from an early age. Wandering through museums and galleries since childhood, she developed an appreciation and respect for the highest qualities in art. At an early age she began her formal study, culminating in a Bachelors and Masters degree in Fine Art. After years of studying both abstract painting and representational art, she was still searching for a deeper understanding of light and color. She discovered Henry Hensche, an American Impressionist painter in the lineage of Charles Hawthorne, William Merrit Chase, and Claude Monet. After years of in-depth study with this master painter, she began to uncover the deep secrets about light and color that she had searched for throughout her life.

Sarback's paintings are always about the quality of light. Her subjects will range from rivers, ponds, and bridges to waterfalls and vistas. "I focus on refining my visual perception and capturing that on canvas. My subject is always light and color. It took years of training to be receptive to light, form, and rhythm and I learned this by painting from life with natural light both outdoors and in the studio. This has enabled me to refine subtle color variations that capture the quality of light, atmosphere and space."

International Artist Magazine named her one of the Master

Susan Sarback with her Wheaten Terrier, Jasper.

Painters of the world. Her paintings have been shown in galleries in New York City, San Francisco, Napa Valley, Sacramento, Seattle, and Santa Fe. Her works are also held in private collections throughout the world, including the Medical Center of the University of California at Davis and the Kaiser Permanente Medical Group in Sacramento. The Cornell Museum of Art and History in Florida includes twelve of her paintings in its permanent collection.

Susan Sarback is the author of *Capturing Radiant Color in Oils,* (North Light Books, 1994) and is the founder of The School of Light & Color in Fair Oaks, CA. Since 1986, she has lectured about color at over 100 art schools, museums, universities, and art associations. Also she has taught painting workshops and classes throughout the U.S. and Europe. Articles by or about her have appeared in *The Artists Magazine, American Artist Magazine, The Los Angeles Times, Sacramento Bee, Sacramento Magazine,* and other publications. In April, 2002 PBS aired a feature segment about Susan Sarback and her paintings: *Central Valley Chronicles* detailed her background, teaching techniques, and her School of Light and Color. She has brought her unique discoveries in Impressionism to Northern California where serious artists from around the world come to immerse themselves in her classes and workshops.

For more information contact the School of Light & Color,
10030 Fair Oaks Blvd. Fair Oaks, CA 95628
(916) 966-7517

www.lightandcolor.com

CONTENTS

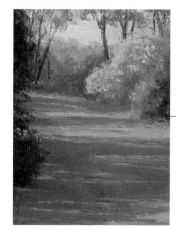
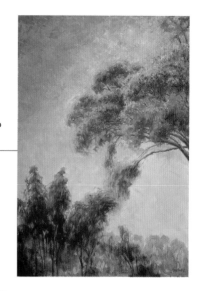
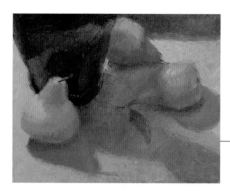

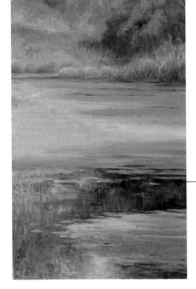

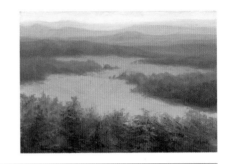

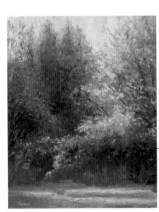

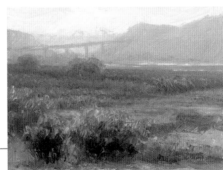

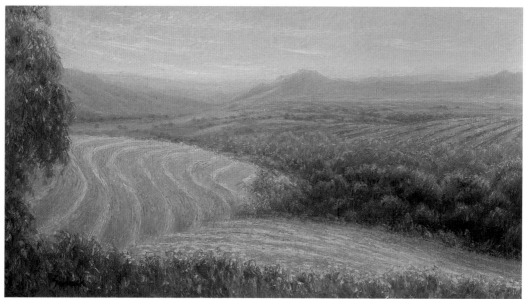

Tuscan Vista, Late Day, oil, 10 x 30 inches, Susan Sarback.

Introduction

There is a radiant color inherent in light. With this book as a guide you can open your vision about seeing and painting light and color. You will actually expand your own color perception and bring this new awareness into your painting. I call this specific method full-color seeing—the way to see and paint color as affected by the surrounding light. This kind of seeing can add an exciting richness to your vision and a radiant quality to your art.

These pages unfold a new language of light and color, a language based on direct visual perception. The initial chapter gives an overview of different ways of seeing and painting color. Then, I explain two vital keys to full-color seeing—receptivity and relaxation. Several important vision exercises follow, and succeeding chapters give step-by-step instructions on painting using full-color seeing. They describe in detail the third key to this approach: seeing color relationships. In this reworked book I've added fresh insights and a deeper understanding, derived from an additional twelve years of teaching since the first book was written.

Students in my School of Light & Color have helped enlighten me on the essentials of teaching this radiant-color approach and verbalizing it clearly. Now I can help you learn far more quickly. Actually, what took me five years to learn, my students are learning in less than one year.

In this expanded revision, I present new paintings, created over the past several years. This is significant, since the new images more accurately depict the principles discussed.

I welcome you to a deeper understanding of these principles and procedures. Let me offer a preview of what you'll learn:

1. How color actually creates form, as well as atmosphere (the weather condition) and distance (the sense of space).

2. How to develop technical skill including the use of paint strokes and texture to enhance form, a greater understanding of edges (soft edges, crisp edges, and lost edges), and the use of a palette knife to create a variety of effects with color.

3. How to gain a more accurate and clearly defined understanding of the four-stage process of capturing radiant light and color. (This is essential for developing quality paintings more consistently, not with a random approach, but with a conscious one).

4. How to see and paint the range of colors we perceive in nature, using both its bright colors and its somber, subtle, and dull colors.

5. How to see and paint the dynamics of cast shadows: shadows cast from opaque objects, from translucent objects, and from transparent objects.

6. How to use this light and color approach with soft pastels.

7. How to use the timeless principles of rhythm, structure, freedom, grace, and balance in your paintings.

8. How to create strong compositions by painting the essence of the landscape: training your eye to simplify your seeing, selecting the strongest landscape subjects, and painting the natural rhythms and patterns in any landscape.

9. How to better understand full-color landscapes by perceiving the light key: how color creates atmosphere in your painting, how light and color unify a complex scene, how we can perceive differences in color under different light conditions, how different times of the day and how varied weather conditions change the light key.

These new and fully revised sections demonstrate an effective approach to study that adds up to fresh, powerful information for any painter.

A LITTLE PERSONAL HISTORY

The journey that led me to full-color seeing began when I was fifteen, attending an art high school in New York City. I spent hours combing art galleries and museums, absorbing all the great works

the city had to offer. Of everything I saw—all the great painters of many different periods—I returned most often to the Monet room at the Museum of Modern Art. The huge expanse of water lilies captivated me again and again.

However, their magic eluded me over eight years as art schools led me down a conventional path. I studied all the traditional subjects: anatomy, design, drawing, composition, and perspective and color theory. I studied traditional approaches to color, including tonal or local color, expressive color, imaginary color and symbolic color. All this fueled my desire to be an artist—but something was missing. Where was the sense of freedom and light I had loved in Monet's work? My paintings didn't come close to capturing this radiance.

Several years after art school, a friend told me about a master painter, Henry Hensche, who taught specifically about light and color. When he gave a workshop near my home in California, I decided to attend. Hensche taught his students how to actually see the way light affects color. His approach to color did not rely on theory or rules, but on an awakened perception. He taught how to see color based on color relationships and the overall atmosphere of light.

I remember watching and listening to him, knowing that this was a true master—and a rare opportunity. I knew that few would get this chance even once in a lifetime. I took copious notes, asked as many questions as I could, and absorbed a tremendous amount from this man.

Hensche's workshops held the missing link I had been searching for.

Driving to his class every morning, I began to notice how the landscape around me looked different. My vision itself was changing. Common everyday scenes were transformed; buildings, trees, cars, even shadows on the road revealed radiant color. Everything was alive, pulsing with light and color. I loved this new way of seeing and was determined to learn more.

I studied with Hensche in the following years until his death in 1992. I spent many summers at his school, the Cape School of Art in Cape Cod, Massachusetts. This school was founded in 1899 by Charles Hawthorne, Hensche's teacher and a contemporary of Claude Monet. Hawthorne was intent on devising a teaching method for painters to learn to see and paint with the vision of the Impressionists. At the Cape School, I learned a new way of seeing and painting; it gave me insight into how to paint with the radiance I had seen in Monet's paintings.

In my first year of classes at the school, I met long-time students of Henry's, and I longed to achieve their level of mastery. I remember asking one of them what it felt like to paint like this. He thought for a while and said, "It's total freedom." From that moment on, I promised myself that someday I would experience that freedom.

> I began to notice how the landscape around me looked different. My vision itself was changing. Common everyday scenes were transformed; buildings, trees, cars, even shadows on the road revealed radiant color. Everything was alive, pulsing with light and color. I loved this new way of seeing and was determined to learn more.
>
> SUSAN SARBACK

In time, Henry showed us that the "secret" to this freedom and beauty lay in seeing with new eyes—dropping all preferences and preconceptions and keenly observing color relationships. Seeing and painting these relationships more and more truly was the key. It sounded so simple. But it was so very challenging. I spent day after day, year after year, refining my vision and my painting skills.

Henry taught me everything I had yearned for. His approach was not stylistic and not based on taste or the popular style of the day. It was based on visual reality. This approach enabled me to glimpse the eternal quality of light and learn to capture it—and to discover that it's not a style or technique, but an incredible direct experience.

I'm confident that every artist can learn this language of light and color, discovering that art and its forms are unique, but color itself is objective. You'll discover that this alive and fresh sense of color gives greater vitality to any subject or style.

One summer afternoon at the Cape School, someone asked Henry what the purpose of painting is. He thought for a moment and said, "The purpose of painting is to lift the veil of mystery into consciousness."

In a sense, what Henry taught about painting was not just about painting. It was about living life fully, about a greater way of being in the world.

I was in my twenties when I first studied his approach to light and color. Now, over twenty-five years later, its impact is just as powerful. I learned not only how to see and paint, but I have the keys to explore realms beyond my imagination.

From the beginning of my studies, I knew that I wanted to share what I was learning. Over the years, through teaching and painting, I learned more and more. In 1986, I founded the School of Light & Color in Fair Oaks, California, where I teach regular workshops and classes.

This book contains the fruits of many years of learning, teaching and painting using the methods of full-color seeing. All is based on what I learned with Hensche and reflects my own personal insights, points of view, and experiences as an artist and an instructor. Today, the most frequent comment I hear from my students is "This has changed my life." The following chapters can lead you to understanding just what these words mean.

Full-color seeing and painting has been of the utmost value to me in my growth as a person and as a painter, filling a longstanding gap in my understanding and my sight itself. My hope is that it may provide an invaluable stepping-stone for you on your journey as an artist.

Susan Sarback

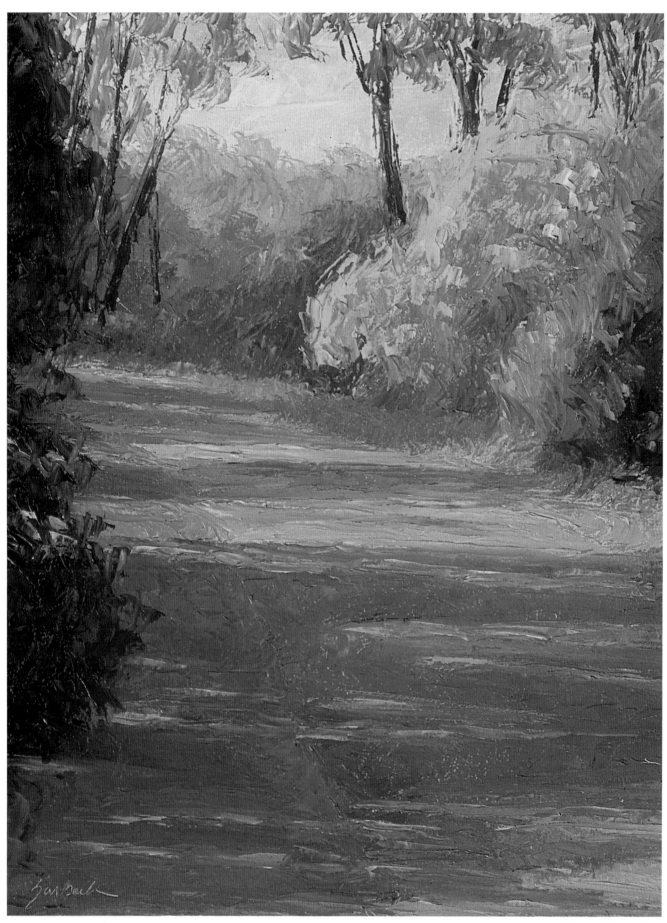

Autumn Path, oil, 11 x 14 inches, Susan Sarback.

Chapter One

Seven Ways
to Paint with Color

The eye is the jewel of the body.

HENRY DAVID THOREAU

The eye, that most wonderful of human organs,
is infinitely perfectible, and it can attain,
when intelligently trained, a marvelous acuity.

GUY DE MAUPASSANT

The artist's eye, grafted on his heart,
reads deeply into the bosom of nature.
That is why the artist has only to trust his eyes.

AUGUSTE RODIN

The real painter humbles himself
and looks at everything with a fresh eye.
For him every painting is a journey of discovery.

HENRY HENSCHE

I would like to paint the way a bird sings.

CLAUDE MONET

Ever since childhood, I've loved creating art. I was always looking for a way to express myself through drawing and painting. As I got older, I attended many art schools and experimented with many different approaches to painting. Eventually, I discovered my passion as a painter rested with light and color. Creating radiant color in a painting fascinated and inspired me most.

In my early studies, I learned to evoke a sense of light using value differences: placing light and dark areas next to each other to produce an effect of light. My paintings resembled life, but they weren't capturing the radiance I wanted. I began to suspect that the key to more light and life in my paintings lay in the choices of the actual colors, or hues, themselves, and not just in their values.

Seven Approaches to Color

I studied many approaches to color and thought of them as a variety of languages. The following is an overview of the seven basic ways of seeing and painting color that I studied: local color, expressive color, color theory, personal color, color from memory or imagination, symbolic color and full-color seeing. These seven categories describe the ways artists have used color throughout history; they used them singly, or more often, in combination. This discussion is not meant as a comprehensive survey, but rather as a background for understanding full-color seeing, the key that finally unlocked the mystery of light and color for me. Not based on a particular style or subject matter, it is a way of seeing and painting color that can be carried into any style, medium or subject matter.

Local Color

These paintings represent examples of seven different approaches to painting light and color. I chose a simple, ordinary scene so that the subject matter would not distract from showing the various ways of using color. You may find it useful to take a single mass and trace its color through the seven paintings. For example, the shadow on the house moves from gray, to neutral, to a bold green and, finally, to a luminous blue in the final example, full-color seeing.

Expressive Color

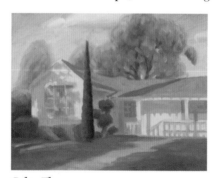

Color Theory

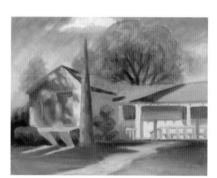

Personal Color

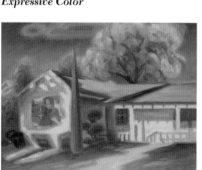

Imaginary Color

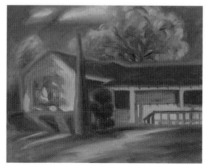

Symbolic Color

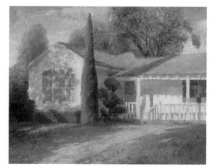

Full-Color Seeing

LOCAL COLOR

Red is the local color of apples; yellow, the local color of lemons; blue, the local color of the sky on a clear summer day. Local color is the color of an object independent of such considerations as the light in which it is viewed or its relation to all the other colors in the field of vision. Thus, grass is green, tree trunks are gray or brown, and the shadow of a tree trunk on grass is simply a darker green. This is how we are often taught as children to see color.

Many of the world's masterpieces have been painted using primarily local color, from the works of the seventeenth-century painter Vermeer and the nineteenth century's Corot to the work of contemporary photorealists.

Local color is an excellent tool for description. It allows us to easily recognize images in representational art; an amorphous green shape atop a brown stick immediately becomes a tree. This ability to create likenesses is one of the pleasures of representational art, and local color can serve this purpose well, but at a cost. For example, if I paint a roundish shape in shades of yellow, you may recognize it as a lemon. Suppose, however, that I am painting outdoors on a late summer afternoon. Painting only in shades of yellow ignores the deep pink light cast by the setting sun on one side of the lemon, the coolish tint cast by the still blue sky from above, and the greenish light bouncing up from the emerald drop cloth. Focusing solely on local color can lead to a kind of visual shorthand in which images are aptly conveyed, but richness and subtlety are lost.

In all the years I painted in local color, I learned only about

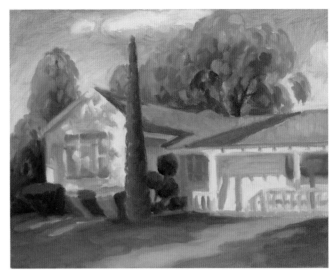

Local Color, oil, 11 x 14 inches, Susan Sarback.

This painting uses primarily local color, the color of our everyday vision. The grass, trees and bushes are a variety of greens; the house is white with gray shadows; and the sky is simply blue with white clouds.

value, not color. Painting with values is called tonal painting. One teacher told me, "You can use any color as long as you get the value correct." Thus, local color became an extension of drawing, using values (lights and darks) to represent the effect of light. I realized I wasn't really learning to see color and knew there must be something more.

EXPRESSIVE COLOR

My next study dealt with expressive color—color based on feeling. This way of painting frees color from the description of natural appearances and allows the artist to respond directly from his deepest feelings and emotions. It relies on intuitive, spontaneous feeling. Van Gogh, with his passionate enthusiasm and love for life, used expressive color to convey his response to his subjects.

Rather than seeing brown hair, the artist might intuit it blue or violet. Instead of observing the color differences between one side of a face and the other, the artist may sense one side pink, the other greenish. To feel color in this way gives the artist a freedom of expression and a release from observable reality. Color is used as a powerful means of expressing and evoking emotions.

Using primarily expressive color in my paintings was a moving experience for me. I could express my deepest feelings about my subjects. For several years, I created abstract paintings with large, flowing forms using expressive color, but after awhile I noticed I was only repeating certain color combinations. My sense of exploration and fulfillment eventually diminished. I still wanted my paintings to capture the radiance of light, but realized that using my feelings to guide my color choices did not really lead in this direction. So I began looking for ways to paint with a more precise knowledge of color.

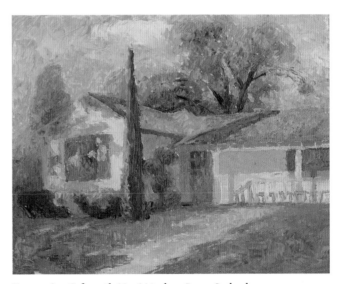

Expressive Color, oil, 11 x 14 inches, Susan Sarback.

A feeling of exuberance is expressed in the bold, direct colors of this painting. The colors were chosen to create an impact of energy and vitality. This type of painting can be very colorful without holding to visual observations.

COLOR THEORY

Rather than painting color based on seeing or feeling, some artists pursue a thinking approach. Theoretical color relies on scientific color analysis or on general rules for commonly observed experiences. For example, many color theorists would point out (as did Leonardo da Vinci) that cooler colors (blues and purples) recede, and warmer colors (reds, oranges, and yellows) come forward; or they might provide a formula for achieving the correct color of a shadow. Artists using a thinking approach often employ these theories to create desired effects in their paintings.

Some renowned color theorists working around the turn of the century were Itten, Birren and Chevruel, whose findings influenced the French Impressionists and the Pointillists. The Pointillists Signac and Seurat based their technique of painting in distinct dots and dashes of pure complementary colors, on the theory that the colors blend in the eye of the viewer.

By the mid-1950s, Josef Albers had established that color is relative. Through analytical studies of color pigments, Albers showed that colors are not perceived in isolation. His aim was to determine how color pigments interact with each other and to reveal the effects colors have on each other. By placing identical squares of a specific color within larger fields of varying colors, Albers demonstrated how the surrounding field influences our perception. A small, green square seen against a red background will appear greener than the same square seen against a blue background. Albers's studies formed the basis of his paintings and those of many artists to follow.

For me, the challenge of color theories is in relating them to my own perceptions. I studied Albers' *The Interaction of Color* and came away with an increased understanding of color pig-

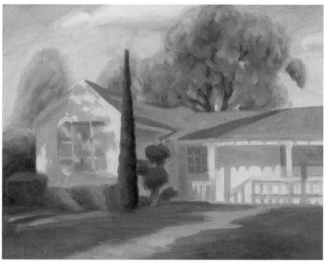

Color Theory, oil, 11 x 14 inches, Susan Sarback.

I used two theories to help determine the color choices in this painting. First is the rule that cool colors recede and warm colors come forward. Second is a formula for cast shadows using the color of the object, its complement and the color on which the shadow is falling. Notice the background trees are cooler, the foreground shadows are warmer, and the cast shadow on the house is an indescribable neutral tone.

ments and color relationships, but I didn't know how to apply this understanding to my own vision. I could relate color pigments and manipulate them to produce certain results on the canvas, but I hadn't learned to see my subjects any better.

In fact, none of the theoretical approaches I studied addressed how to actually see color. Although some of the theories I learned sensitized my eyes to color relationships, I was not satisfied to paint mainly from a theoretical approach.

PERSONAL COLOR

Personal color is a term I use to refer to purely individual color choices, based on color harmonies that the artist finds pleasing, unusual, or on seemingly arbitrary, random colors. Personal color became popular in painting during the middle of the 20th century as artists experimented in moving beyond their predecessors. Abstract artists like Jackson Pollock and Helen Frankenthaler displayed less interest in color theory and descriptive color than in abstract problems disassociated from objective reality. They used color abstractly, without necessarily any external or emotional reference. Personal color is like expressive color, but less emotionally or mentally derived; it is simply based on the personal choice of the artist.

As in my experiences with expressive color, I eventually found myself repeating my own color preferences in my personal color paintings. Once again, restlessness gradually replaced my initial sense of freedom and excitement.

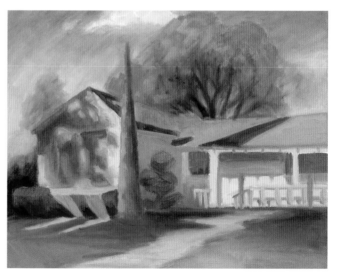

Personal Color, oil, 11 x 14 inches, Susan Sarback.

This painting is based on a range of colors—blues, purples, violets, and reds—selected to create an unusual effect. The intention is not to describe nature or create an emtional impact. Personal color can be rather arbitrary, as in this case, or can tend more toward decorative, pleasing effects.

COLOR FROM MEMORY OR IMAGINATION

Many painters throughout history have painted either from memory or imagination. Some make quick sketches or begin paintings outdoors, then rely on memory to complete the painting indoors. Others, like Marc Chagall, combine elements in a way not seen in this world and paint imaginary scenes. Still others, like surrealists Salvador Dali and Rene Magritte with mystical paintings and illustrations, work from an inner vision they bring to life on canvas.

Memory and imagination both involve the creation of a mental image that can then be used as a source for painting. I discovered that the mental images I was able to create were too generalized to serve me well. They did not capture what most interested me: the quality of light at a specific time and place. Leonardo da Vinci spoke of this limitation when he said:

> *Whosoever flatters himself that he can retain in his memory all the effects of nature is deceived, for our memory is not so capacious; therefore consult nature.*

After prolonged study, however, the memory begins to retain more and more information. Monet, through years of continued observation from nature, had so developed his visual memory of light and color that he was able to successfully complete paintings in his studio that he had begun outdoors.

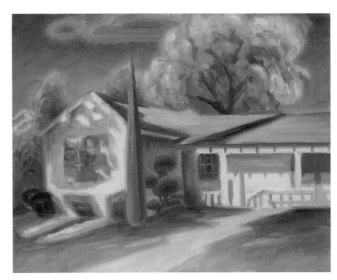

Imaginary Color, oil, 11 x 14 inches, Susan Sarback.

The colors in this painting were chosen to create a world apart from observable reality. For example, orange clouds in a green sky with blue land and an oragne bush glowing in the shadows could exist only in the imagination of the artist.

SYMBOLIC COLOR

Colors often carry symbolic meanings within a given culture. In Western culture, black is a sign of mourning, where in some Asian cultures, other colors, such as purple or cream, are worn for mourning. Artists can make use of these symbolic meanings in their work. Many religious, allegorical and traditional art forms rely on symbolic colors to help convey their message.

I discovered symbolic color in my search, but my interests leaned toward light and perception, and away from conceptual meanings associated with specific colors.

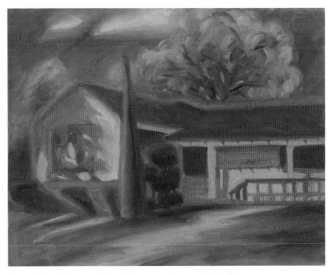

Symbolic Color, oil, 11 x 14 inches, Susan Sarback.

The colors in this painting have been chosen for their symbolic value. The red house stands for the security and warmth of hearth and home. The surrounding dark grays represent the stormy challenges of life. This is just one example of how this scene could be painted using symbolic colors to make a statement.

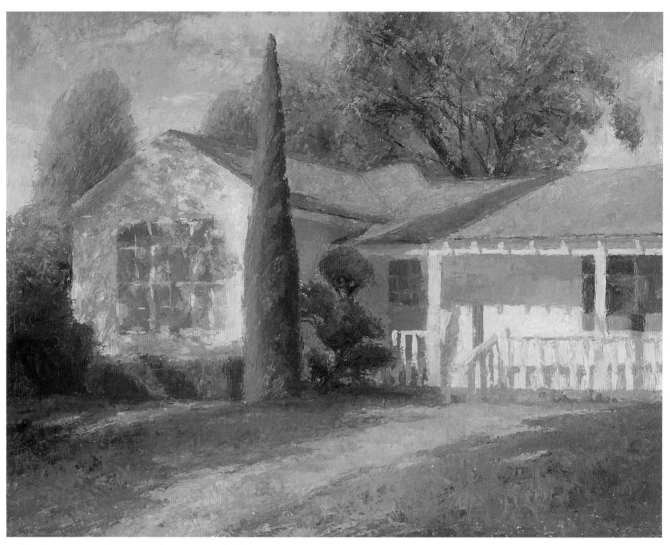

Full-Color Seeing, oil, 11 x 14 inches, Susan Sarback.

This was painted on a sunny morning with careful observation of how the pervading light affected each color. The color choices are based purely on visual perception, not on theory or emotional expression. Compare the colors of some of the masses with the other paintings. Notice the sense of radiance and light this approach imparts.

FULL-COLOR SEEING

After I graduated from art school, I continued to attend workshops, classes and seminars. I often asked my teachers how to paint the color of a cast shadow. One teacher said that a shadow may be blue but is usually a neutral color, such as gray. Another suggested a formula: Take the color of the object casting the shadow, mix it with its complement, and blend this mixture with the ground color on which the shadow falls. Still another told me to simply make the shadow color a deeper value of the ground color.

Finally, I found a teacher, Henry Hensche, who taught me how to see the way light affects color. He showed me that artists can learn to simply see the color of a shadow. Sometimes a shadow is blue, sometimes violet, green or a complex hue impossible to describe in words. It could be any color. Color is based not only on the local color of the object, but on all the colors surrounding it, the way the light is hitting it, the time of day, the season, the atmospheric conditions, the viewer's distance from the object—too many factors for a formula to incorporate.

Hensche developed a method of teaching how to see the way light affects color. This way of seeing color is based on direct observation from life rather than on imagination, theory or memory. It relies solely on vision. I call this expanded color vision full-color seeing, because it is a way of seeing the full range of color. This vision was the key to the light and radiance I had been looking for all those years.

The Impressionists, especially Claude Monet, saw the way light affected color—the way an object appeared to be different colors at different times of the day and under varying weather and seasonal conditions. Monet's series of haystack paintings supremely embodies this understanding. The local color of a haystack is the color of straw, yet Monet saw and painted them using the entire spectrum of light, from reds and oranges to greens, blues and violets.

Full-color seeing is the vision of Impressionism. The Impressionists were interested in light and atmosphere. Yet to see with this vision does not mean one has to paint in the style of the Impressionists. Full-color seeing can be applied to well-defined, carefully rendered forms as well as to loose, flowing, soft forms.

Since full-color seeing is based on visual perception, I want to briefly talk about how we see. Learning full-color seeing is learning a new vision. What is the main factor that determines how and what we see?

Our eyes are extremely sensitive, yet our vision is notoriously inconsistent. Experiments show that a person sitting in a totally dark room can register the impact of a single photon of light on the retina, yet crime studies reveal that eyewitnesses are, in fact, highly unreliable and often contradict each other. What causes this? *In Help Yourself To Better Sight* (Prentice-Hall, 1949), Margaret Darst Corbett, an expert in the field of visual training, explains:

> *We see, hear, taste and smell with the mind. If you attempt to study, your attention elsewhere, you learn nothing of your subject. If you pass through a rose garden, your mind intent on things beyond, you fail to catch the perfume of the blossoms....The sense organs are merely aids to their respective brain centers; it is the mind that perceives. If the mind is tense and strains or is temporarily absent, the senses cannot function.*

One way the mind determines what we see is by filtering out information we perceive as unnecessary. We gradually become accustomed to a stimulus and then begin to tune it out as it loses its immediate relevance or newness. For example, if someone in the next room turns on a radio while you are reading, at first you may be distracted, but eventually the sound of the radio blends in with the other ambient sounds, and you are able to continue reading undisturbed.

This is a valuable mental process that occurs automatically many times daily, but it can work against us as we paint. Light surrounds us every day. With the exception of special effects, such as a beautiful sunset or the sky before a storm, we usually overlook the particular quality of light at any given moment. By learning to see with an increased awareness, we catch the subtleties of light and color that normally are lost to us.

Seeing Beauty

Learning to see the full range of color deepens our appreciation for the beauty in the world around us. A woman wrote to me about how she was still benefiting from one class she had taken more than two years before, even though she had not painted since:

> *I am very much aware of the infinite and constantly changing colors in my environment. Grays and browns don't exist. They have become subtleties of other colors. The bark on a eucalyptus tree can stop me in my tracks to take in its beauty. A day-long drive into the desert...is awesome as the light changes everything all the time. Rocks seen while camping are delicate purples, greens, blues and pinks...My universe is now a constantly changing palette of colors... This way of seeing changed my life.*

I have seen full-color seeing and painting add meaning and value to my life and to the lives of many others. In the next chapters, I will present the foundations of full-color seeing, beginning with how to see and then moving into actual painting techniques.

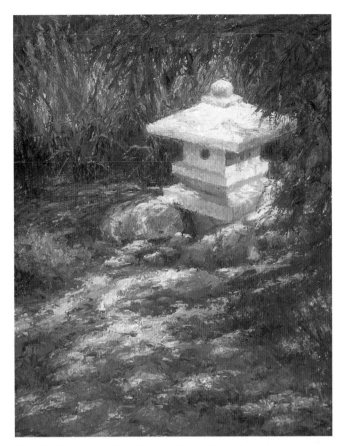

Temple Garden, oil, 16 x 20 inches, Susan Sarback.

The rhythm and pattern of light seen on this sunny late afternoon reveals a spectrum of color in a simple scene. Beauty is everywhere. Ordinary scenes can become luminous paintings of light and color.

TIPS

Seeing With Fresh Eyes

The colors that you see and paint will be based on:

- the time of day
- the season
- the weather condition
- all the colors surrounding your subject
- the way the light is affecting your subject

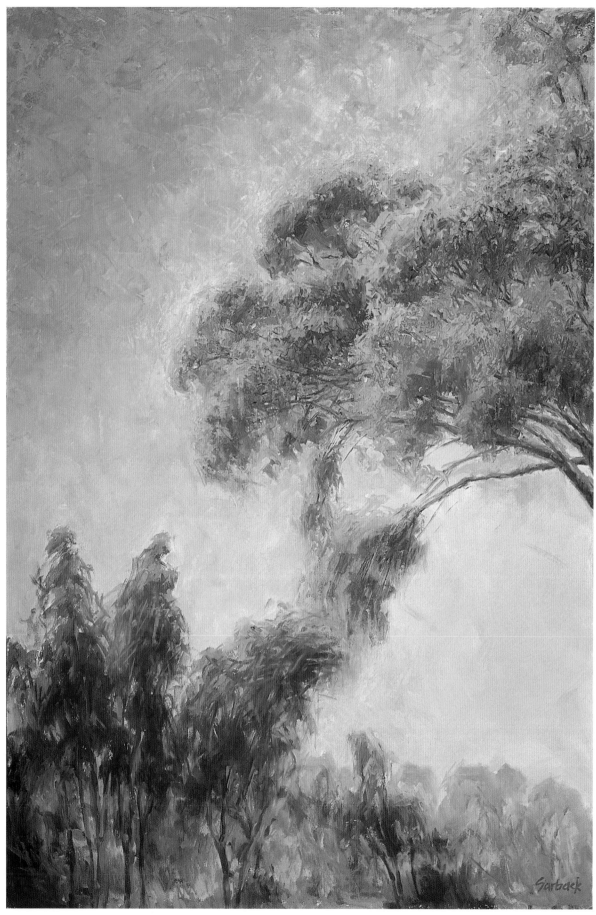

Reaching for More, oil, 16 x 24 inches, Susan Sarback.

Chapter Two

How to
See in Full-Color

I want to be right not in theory but in nature…
to achieve progress nature alone counts,
and the eye is trained through contact with her.
PAUL CEZANNE

The richness I achieve comes from nature…
Perhaps my originality boils down to being a hypersensitive receptor.
CLAUDE MONET

Anything under the sun is beautiful if you have the vision—
it is the seeing of the thing that makes it so.
CHARLES HAWTHORNE

There is nothing more difficult for a truly creative painter
than to paint a rose, because before he can do so
he has first to forget all the roses that were ever painted.
HENRI MATISSE

Without seeking to do so, one discovers newness, and this is much
better. Preconceived theories are the misfortune of painting and painters.
CLAUDE MONET

I don't know a better definition of an artist
than one who is eternally curious.
CHARLES HAWTHORNE

I once saw a film of Claude Monet painting. He stood before his easel, painting outdoors in his garden. He looked out at the flowers, mixed a color on his big palette and applied it to his canvas. At first I saw nothing unusual, but after a moment it struck me—Monet was utterly relaxed. His hands were loose and flowing as they moved from palette to painting. His head nodded in a barely perceptible rhythm. All the muscles of his face were relaxed. Even his eyes and lips looked limp. He imparted a feeling of ease and fluidity, like a calm, peaceful river.

Relaxation and the open, receptive state it fosters are keys to full-color seeing. While instructing a young painter, Claude Monet explained: "But I don't teach painting. I just do it . . . there has been and will be only one teacher . . . that, out there." And he showed him the sky. "Go and consult it, and listen well to what it tells you."

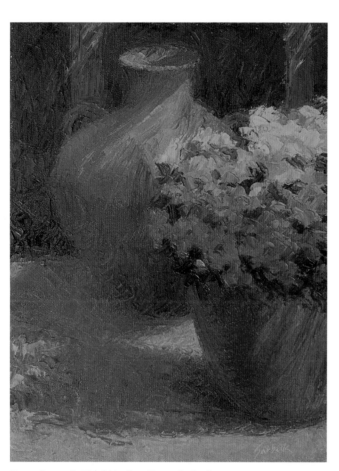

Impatiens, oil, 11 x 14 inches, Susan Sarback.

This was painted on my deck on a sunny summer morning. As I viewed the scene, I stayed loose, relaxed, and at ease. With gently squinted eyes I was able to see beyond the local or obvious colors. Notice how the shadows are a range of colors leaning towards the cool side of the spectrum—bright violets, magentas, blues, and dull greens. These enhance the warmth and brightness of the flowers which are partially sunlit.

Relaxation and Alertness

During the 1988 Summer Olympic Games, a runner who had won a gold medal was asked what was most important to his success as a runner; what he concentrated on most while running. "Being relaxed," he answered.

I can see color beyond my everyday vision only when I am relaxed. I have to be relaxed and alert at the same time and look for what the light can show me. This combination of ease and activity enables me to be receptive and sensitive.

The writer Aldous Huxley stated this principle clearly in his book *The Art of Seeing* (Berkeley, 1982): "The secret of efficiency is an ability to combine two seemingly incompatible states—a state of maximum activity and a state of maximum relaxation."

Huxley wrote his book because of success he had improving vision without the use of corrective lenses by following exercises devised by Dr. William H. Bates, the author of *Perfect Sight Without Glasses.* Huxley distinguishes two kinds of relaxation: passive and dynamic. Passive relaxation is a state of complete rest, free of muscular and psychological tensions. Dynamic relaxation, on the other hand, is active rather than passive. It is a state of being relaxed while engaged in physical and mental activity. Dr. Bates held this principle as central to all creative endeavor, saying that the secret is to stay relaxed during activity.

Our vision is just like any of our activities: We perform it best when we are free of tension, yet active and alert. Full-color seeing requires the eyes to be relaxed and constantly moving. Often, our habits are exactly the opposite; when we want to see something better, we fix our vision and stare at it; we look harder at it. This only causes strain, which reduces our ability to see.

Scanning

Scanning is my term for the relaxed, constantly moving vision that promotes full-color seeing. When we scan, the eyes sweep lightly across the field of vision, never locking on any particular object. The head moves gently back and forth, and the eyes move with the head. This motion can be subtle or pronounced and helps prevent rigidity and tension. Scanning is the opposite of staring. The

Dappled Light, oil, 11 x 16.5 inches, Susan Sarback.

As I worked on this painting, I continually scanned the subject, keeping my eyes gently moving. This enabled me to see the blues and purples of the dappled shadows on the wall intermixed with the pinks and yellows of the sunlight.

eyes stay loose and gently keep moving over everything in view.

Before I learned the more relaxed vision of scanning, I sometimes became very tense as I worked. In art school, I noticed the same tension in other students. Some worked with severe concentration—with clenched teeth, locked jaws, and straining eyes. In marked contrast were those whose faces were completely relaxed as they worked. When I was tense, my work became tight and fussy, but when I relaxed, my work had more freedom and aliveness.

Today, I get my best results when I relax and scan. I use several techniques to relax my eyes and help myself scan when I paint.

Exercises for Better Vision

Relaxing the facial muscles, especially the jaw, helps relieve strain in and around the eyes. Researchers, investigating why women applying mascara often let their mouths fall open, discovered a connection between a slack jaw and relaxation of muscles around the eye. When I paint, I often let my eyelids drop slightly and my jaw go slack; this helps me to relax and move into full-color seeing.

The Swing, breathing and blinking, and palming are other techniques for relaxing the eyes.

THE SWING

The basic principle behind the Swing is that tension is not fully relieved by sitting or by lying down, but by doing something active, because muscular activity soothes nerves.

In her book, *Help Yourself to Better Sight*, Margaret Darst Corbett describes several exercises for entering into a state of dynamic relaxation. She describes the principles behind the Swing as:

> *...a return to nature where rhythm in motion is the rule. The race horse in the stall weaves from side to side, the animals in the zoo sway back and forth, not from impatience but to soothe nerves and release tension. Wild elephants gathering in the jungle rock from side to side and swing their trunks rhythmically, weaving as in a dance. Immobility and rigidity are the products of civilization and the beginning of tension and nerves. So, free the large muscles of their tension first by rhythmic motion. These large voluntary muscles will transfer sympathetically their vibrations to the more minute involuntary muscles, including those of the eyes.*

To do the Swing, stand with your feet shoulder-width apart and continuously turn your torso, shoulders and head from left to right and back in a semicircle. Pivot on the balls of your feet as your weight shifts back and forth. Let your arms swing freely. Let the shoulders and head move together, and the eyes with them, sweeping in an arc, without stopping to rest or focus on any one object.

Let your mind be indifferent to what it sees, making no effort to perceive. Simply swing back and forth, skimming your eyes lightly across everything in view. The objects in your field of vision will begin to slip past you as you move, almost like looking out the window of a moving train. Surrender to the rhythm as you would to a dance or a childhood game. I often do the Swing about thirty to sixty times as a warm-up exercise to help my eyes relax before I paint.

BREATHING AND BLINKING

Deep, steady rhythmic breathing is an ancient method of relaxation as well as a cornerstone of good health. It is also essential to sight, as anyone can demonstrate by holding the breath until vision dims. Unfortunately, many times we do exactly that; intent on a task, we hold our breath or breathe shallowly, reducing oxygen to the eyes and inhibiting our vision. We want to be able to focus our attention while remaining relaxed and continuing to breathe deeply.

Frequent blinking is another way to break the spell that we sometimes fall into while concentrating. Blinking moistens the eyes and helps keep the vision fresh.

PALMING

When your eyes are tired, you will not see well. One way to give the eyes a rest when painting is to take a break and look into a dark, shadowy area. Another is to go indoors for a few minutes. Still another is a simple exercise called Palming.

We place extraordinary demands on our eyes—even the books and movies we enjoy in our leisure time require vision. Often, the rest our eyes get while we sleep is simply not enough. Palming is an exercise devised by Dr. Bates to completely rest the eyes. It can be done whenever the eyes need refreshment—before painting as well as during breaks.

Simply close the eyes and cover them with the palms, the bot-

tom portions of the palms resting on the cheekbones and the four fingers of each hand overlapping on the forehead. Let the hollow of your hand leave room for the eyes to open or blink if they wish; don't press on the eyes themselves. You may want to shake or rub your hands initially, to loosen and warm them. The idea is to create a warm, comfortable, dark haven in which the eyes can totally relax. Several minutes of palming gives the eyes a chance to let go of tension.

The eyes and mind work together, so when you're palming, relax your mind as well. Give yourself a break from whatever mental chatter or concerns may have crept into your head. With this combination of mental and physical relaxation, your eyes will emerge rested and refreshed, ready to see again.

Painting While Relaxed

How does an artist paint using this relaxed vision? Suppose I'm painting a landscape by a river. To enter a relaxed, receptive state, I begin by doing the Swing, gently turning back and forth as my eyes move across the scene, never resting on any particular object. When I'm looking to see color, I do not see water, rocks or tree, grass, hills or sky; I see only masses of color, one next to the other. After I do this for a few minutes, I am ready to begin painting.

I continue to keep my eyes moving, never locking on a particular mass or object. Staring into a color causes the eyes to register that

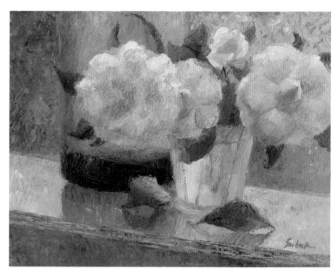

White Camellias, oil, 11 x 14 inches, Susan Sarback.

These camellias were in full shadow indoors on a window sill. Only a small portion of the background was in full light (the upper right corner). I was able to see the range of colors in these white flowers —blues, purples, violets, greens, and yellows by staying relaxed and continually scanning.

color's complement as an afterimage, which makes it look duller, because mixing complements—like red and green, blue and orange, and purple and yellow—creates gray.

Across the Street, oil, 9 x 12 inches, Susan Sarback.

This was a quick plein air painting completed in about one hour. When scanning always look for the specific color differences between the large masses. For example, notice how the warm yellowish grasses in the foreground are clearly different from the distant bluish trees.

Pond—California Winter Sunset, oil, 12 x 16 inches, Susan Sarback.

The eyes tend to tire quickly on bright days with high contrast between sun and shade. This is a late day scene, painted just as the sun was setting. This time of day is more restful for the eyes, but I had to paint very quickly to capture the fleeting light with its subtle color distinctions.

If we stare at a red apple, our eyes will supply green to complete the spectrum. Since green is the complement of red, the intensity of the red appears to diminish. Thus, the more deeply we look into that apple, the more the brightness of that red recedes from our vision. When we stare into a color, we neutralize our color vision, and everything looks duller than if we keep our eyes moving.

Instead of staring, keep your vision soft, shifting easily from object to object. Rather than looking into an object, glance across it, and look next to it, above it and below it. Move your eyes constantly across the whole scene. Always keep the eyes moving—an important key to full-color seeing.

If you paint in a relaxed, receptive state, you become open to a new vision of light and color. Your paintings will then begin to reflect clear, radiant color.

Seeing with Freshness

I once knew a man who lived consistently in a state of wonder. At the age of one hundred, he still maintained the wondrous vision of a child. He had a love for everything he saw, perceiving the simple beauty of a thing before its function.

One day, I handed him a large, common shell. He looked inside it, examining the variations of color and texture with loving eyes, looking as a child would, as if for the first time. He turned it carefully, noting each hue and convolution of the shell. I never saw anyone appreciate beauty as he did. His vision was remarkably clear and fresh.

Orange & Square Vase, oil, 9 x 12 inches, Susan Sarback.

Notice the range of colors in these cast shadows on the table top. They are not shades of gray but unusual blues and greens. The shadow side of the orange is a mixture of greens violets, oranges, and reds – not what you'd expect from an orange! I had to let go of the idea that an orange is only orange and a cast shadow is only gray. I needed to simply trust my ability to see the full spectrum of color.

Full-color seeing relies on this fresh vision—the vision that is willing to see everything as if for the first time. To be receptive to a new way of seeing, we have to not only relax but also open ourselves and make room for the new. Often, we have to set aside our beliefs, preconceptions, judgments and preferences. Free of our old habits, we begin to see with renewed clarity.

When I started studying full-color seeing and painting, I thought I already knew quite a bit about color. It was only logical that a blue tabletop in sunlight would be light blue, and so that's what I saw. Later, I learned to see the traces of pink or yellow or orange. Before full-color seeing, I expected colors on a somber, cloudy day to have a dull, grayish cast, and I saw them accordingly. With full-color seeing, I learned to see the rich, deep colors that weren't gray at all.

Our perceptions come to us through the filter of our beliefs. Often our commitment to our beliefs and preconceptions is greater than our trust in the truth of our immediate experience. Full-color seeing means letting go of limiting beliefs and trusting our vision.

Preconceptions

Let's look specifically at how our beliefs affect what we see. Some of our beliefs are taught to us, and many are formed by generalizing from our experience. We make generalizations to help us function in everyday life. For example, every time we enter a new building, we don't have to examine the front door to determine if it operates similarly to other doors. We simply walk through. "Seen one, seen 'em all," the mind assumes.

This tendency to generalize can be a hindrance as we paint.

> To see in full color, we must let go of these general beliefs and *simply allow ourselves a direct experience in the moment.* This is a state of freshness and wonder. From it, discovery and beauty emerge.

"Don't bother looking at that apple," the mind will tell us, "No need to waste precious time. I already know apples are red." Or a slightly more painterly version, "No need to see the shadows, I've got them all figured out for you. They're always cool, usually blue-purple." The mind will tend to summarize experience into a rule until it is trained otherwise.

To see in full color, we must let go of these general beliefs and simply allow ourselves a direct experience in the moment. This is a state of freshness and wonder. From it, discovery and beauty emerge.

Painters often carry beliefs that limit their experience of this fresh vision. I remember once watching two beginning students set up an outdoor still life. A wide strip of dirt appeared in the background of their composition. "I don't want to paint dirt," each said. They did not see its simple beauty—deep violet in shadow and a rich, warm reddish color in the sun. When we let go of the way we think something is and open to the direct experience of our vision, we can see the full range of light and color.

Often, we don't realize our limiting assumptions until we begin to try to see without them. Beginning students of figure drawing are often amazed to learn that the eyes are positioned not in the upper part of the head, but in the center. Our view of color in nature is subject to the same kind of preconceptions—trees appear green, the sky blue. But we can discover a variety of subtle colors, some strikingly different from the obvious. A white bowl in sunlight at first appears white in the sunlit portion, and simply dark or gray in the shadow portion. With full-color seeing, a painter may see beyond these everyday expectations and catch perhaps some pink, yellow or orange in the sunlit part, and in the shadow area, blues, violets and greens.

FULL-COLOR SEEING COMPARED TO LOCAL COLOR

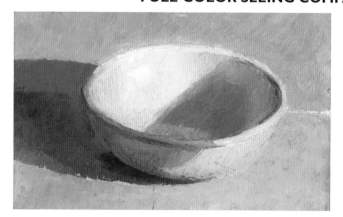

Full-Color Seeing

Local Color

Compare each area of these two paintings. The painting showing full-color seeing has colors we might not expect in a pure white bowl—yellow, orange, pink, purple, violet, blue and green. The bowl showing local color has only shades of gray. The full-color seeing bowl was painted with only pure spectral colors and white, while the local color bowl was painted with black, white and only a few colors.

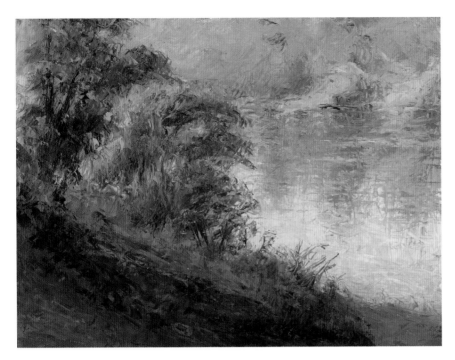

Across the River, Late Day,
oil, 9 x 12 inches, Susan Sarback.

This early morning plein air painting taught me how the warm light of this time of day can envelop a subject. My preconception was that the river was a cool color, but what I saw was this golden light creating woven colors of pinks, yellows, blues, and greens.

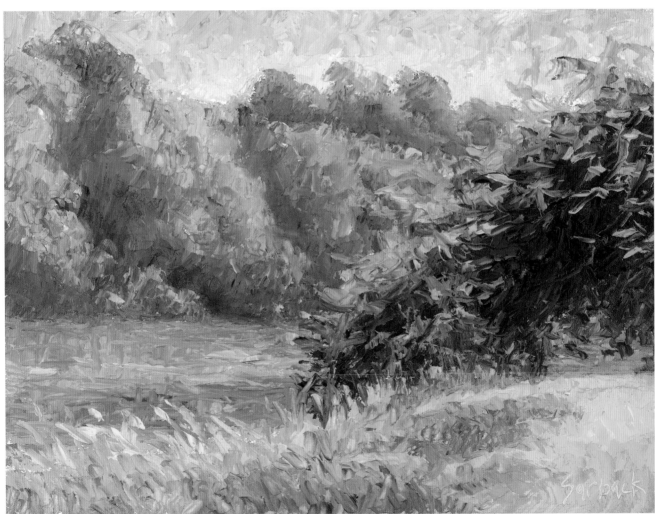

The River Bank, oil, 9 x 12 inches, Susan Sarback.

I used to believe that the same types of trees would be similar in color. Notice the colors of the foreground tree: bright yellow greens in the sunlight and deep purples, blues and greens in the shadows. But, across the river, these same trees appear totally different. The trees with direct sunlight are pinkish yellow and not very bright, while the shadow sides of these trees appear bluer, lighter, and duller. I realized that atmosphere and distance change the perception of color.

Seeing As If for the First Time

American painter Fairfield Porter knew the value of a fresh vision: "I painted a view recently. A great big painting. And it's because I looked out a window and saw it as if for the first time, in a new way....What I admire in [one artist's] paintings is that they remind me of a first experience in nature, the first experience of seeing...." In speaking of the Spanish painter Velazquez, Porter said: "He leaves things alone. It isn't that he copies nature; he doesn't impose himself upon it. He is open to it rather than wanting to twist it." (Fairfield Porter, Boston: Museum of Fine Arts, 1987)

Monet went so far as to say that he wished he'd been born blind and then had suddenly gained his sight, so that he could have begun to paint without knowing anything about his subjects. He held that the first real look at the motif was likely to be the truest and most unprejudiced one. This is the attitude behind full-color seeing.

Preferences

"Taste is the enemy of creativeness," said Picasso. Suppose you dislike the color yellow. You may tend to overlook yellow when you paint. The yellow on your palette may rarely be touched. Or, conversely, perhaps you prefer the warm end of the spectrum—the yellows, oranges and reds; you may then have a harder time seeing the cool colors. While learning full-color seeing, it is useful to drop color preferences and aversions.

My own preferences tended toward muted, cooler colors. I specifically remember the difficulty I had as a student learning to see warm colors in shadows, especially shadows on grass. I saw green, with touches of blues and purples, but I saw no hint of warmth. Along with preferring cool colors, I had the notion that shadows consist of merely those hues. I didn't quite believe there could be

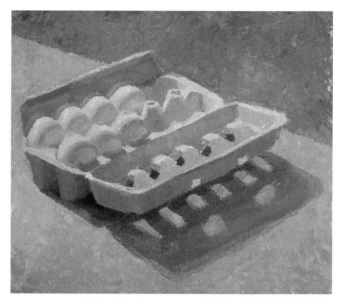

Egg Carton, oil, 12 x 13 inches, Susan Sarback.

The fresh vision of full-color seeing can transform ordinary household items into objects of radiance and beauty. This study of white eggs on a gray carton shows the full range of color found in a sunny day.

any trace of red or orange in a lawn in shadow, so I didn't see any.

Only after careful study of paintings I admired did I open to the possibility of other colors in the shadows. If other artists had seen warmth in shadows, then perhaps I could, too. Of course, opening to this possibility did not instantly change my ability to see warm colors, but it was a starting point. Occasionally, as an exercise for myself, I chose subjects that were extremely warm, bright and bold. This helped me overcome my preferences and learn to see the entire spectrum of color.

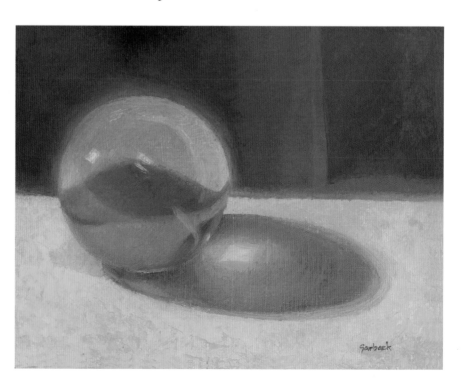

The Marble, oil, 11 x 14 inches. Susan Sarback.

This clear glass marble showed me how the complete range of color exists everywhere.

I had to visually study this subject as if I had never seen it before in order to notice that both the marble and its cast shadow contain the full spectrum of colors.

Moving Beyond Limits

A beginning student in one of my workshops was not seeing red. His paintings included the rest of the spectrum, yet he was unaware that he was avoiding red. First, I helped him see, to his surprise, that he had used every color on his palette except red. I then suggested that he paint several studies of red objects. He painted on cloudy days and on sunny days so that he could see red in different kinds of light.

By putting sustained attention on seeing red, he finally overcame his dislike, and in doing so, broadened both his appreciation and his vision. In painting ripe tomatoes, he saw the beauty of the color, its variety of rich, deep notes.

You can begin to identify your preferences by examining your paintings. Also pay attention to other times when you make color choices—clothing, interiors, works of other artists you admire. Notice if your choices lean toward the cool side, the warm side, high contrast, neutrals, light, dark and so forth.

Often when painters rely heavily on certain colors, others are being neglected. For example, the painter who avoided red was overusing orange and violet. If you have a preference, make a special effort to explore other color choices. If you have a color aversion, make a point to use the color until you become comfortable with it. In this way, you expand your appreciation and experience a greater variety of beauty.

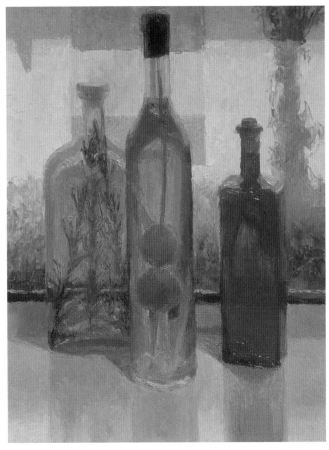

Three Bottles on a Sill, oil, 12 x 16 inches, Susan Sarback.

I chose a bold subject of bright, warm colors to help me go beyond my preference for subdued, cooler colors. The warmth of the red and yellow bottle against the sunlit wall on this hot summer day made it easy to see and appreciate this warm side of the spectrum.

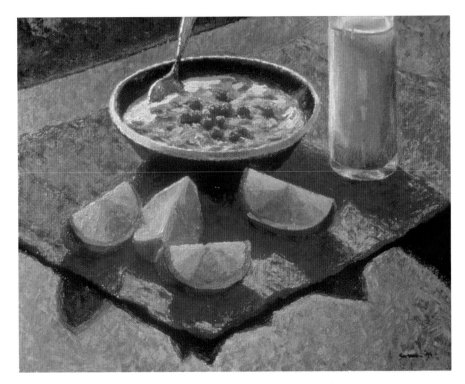

Breakfast, oil, 20 x 24 inches, Susan Sarback.

Here is an example of a painting that could be used to explore the color orange. Even though the local color of the orange slices is orange, you will also see yellows, greens and reds. Painting subjects that incorporate similarly colored objects helps us see the subtle variations of that color.

EVERYDAY VISION COMPARED TO FULL-COLOR SEEING

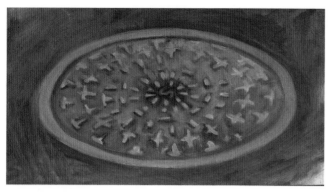

Everyday Vision

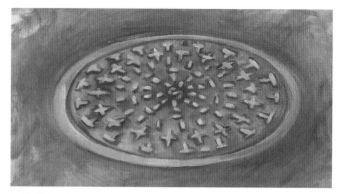

Full-Color Seeing

These two studies are of the same subject, a manhole cover on a sunny day, but each is painted with a different vision. The first is painted using my everyday vision and the second, using full-color seeing. Notice how the first version misses the radiance and intensity of direct sunlight. Full-color seeing is the key to capturing the effects of light.

A New Way of Seeing

One day after class, one of my students called me on the phone, her voice full of excitement. She said that when she got home she saw a blue spot on her stainless steel sink. Thinking something had spilled in the sink, she got her cleanser and began scrubbing vigorously, trying to clean it up. Finally she realized it wasn't coming off—there wasn't anything on the sink at all. She was simply seeing the blue color from the way the light touched the stainless steel, a color she'd never noticed before. Pleased and surprised, she told me, "I had no idea this workshop could so completely transform my day-to-day vision."

This vision of full-color seeing is marked by curiosity, wonder and the ability to see each object as something new. Labeling things can stop us from seeing what they really are. Painters can form the habit of seeing objects—just shapes and colors—without attaching names. I had an experience one day that showed me the difference this fresh vision can make.

As I was stopped at an intersection, I happened to glance over at a manhole cover. I thought, "What a common, mundane object." It was just a thick, dense slab of metal. But then I switched to my painter's vision, full-color seeing. I looked again at the cover as if I were going to paint it. I noticed that the raised lettering on the cover captured the sunlight in interesting ways. I saw patterns of light, shapes and colors.

It became more and more beautiful. Instead of a manhole cover, it became like a Mayan sun symbol, radiant and glowing. In only a moment, I had moved from my everyday world into a world of deep beauty, just by shifting my vision. When I dropped my expectations about manhole covers, I had a new and greater perception.

To paint with the freshness of full-color seeing, it helps to be curious, take breaks and trust your vision!

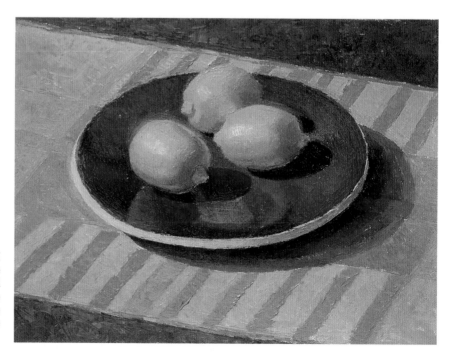

Lemons on a Black Plate, oil, 20 x 24 inches, Susan Sarback.

I was surprised by the full-spectrum of color I saw in the black plate in this painting. I became fascinated by the range of deep rich color found in this flat, black object in sunlight…. Notice the variety of colors in the shadows and the reflections of the lemons on the plate—all were mixed without using black.

BE CURIOUS

Explore and discover. When we look at something as though we're seeing it for the first time, it's always a surprise. We are open to seeing things we've never noticed before—like the woman who saw the blue spot on her sink. A deep curiosity about life transforms everything into something special, helping us to love seeing and to love life, giving us the key to seeing beauty in all things.

TAKE BREAKS

To keep your vision fresh, take occasional breaks from your painting. You can walk away from your scene in order to return and see your painting as if for the first time. You can do seeing exercises, such as the Swing, described earlier, to release tension and move into a receptive state. You can stop, close your eyes and clear your mind, perhaps using a relaxation technique, such as deep breathing or palming.

TRUST YOUR VISION

In one of my weekend workshops, a painter was struggling with a study of a lavender bowl in direct sunlight. He had painted the shadow side of the bowl a blue-green. Exasperated, he called me over. "I'm losin' it," he said. "I just can't do it." I glanced at the bowl and back to his painting, and saw, on the contrary, that his color was quite accurate.

Trust your vision. Assume that your initial impressions are correct and go with them. Don't concern yourself with being right or wrong. Simply realize that the process is one of continual refinement.

Often we rely heavily on our intellect to solve our problems. It takes trust and courage to allow the solution to emerge directly from our sensual experience. This fresh vision is the source for growth into a mature perception. As painter Charles Hawthorne expressed it, "We must train ourselves to keep and preserve our fresh and youthful vision along with all the experience of maturity."

TIPS

Seeing With Freshness

1. Keep eyes, jaw and face relaxed.

2. Scan your subjects. Keep your eyes moving.

3. To see color, don't look directly into your subject.

4. Be aware of your preconceptions. Don't rely on what you think the color should be.

5. Be aware of your color preferences and aversions. Experiment with a wide range of color.

6. Look at things as if for the first time.

7. Take frequent breaks.

8. Develop your sense of curiosity and wonder.

9. Trust your vision. Don't be afraid to make mistakes. It's only paint; you can always change it.

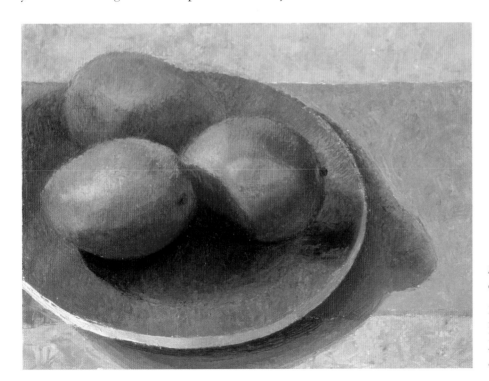

Mangoes on a Black Plate,
oil, 20 x 24 inches, Susan Sarback.

Even though mangoes are multicolored fruit, I noticed a much wider range than I expected. Once I trusted my vision, I was able to see these remarkable, brightly colored objects.

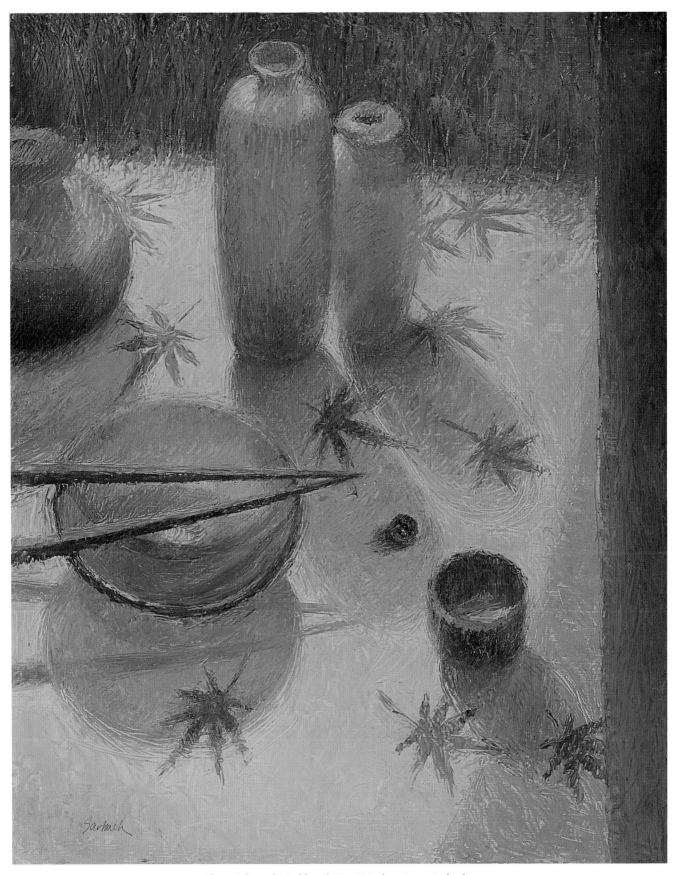

Chopsticks and Marble, oil, 16 x 20 inches, Susan Sarback.

Painting a Simple Color Study in Oils or Soft Pastels

When you go out to paint,
try to forget what objects you have before you…
merely think here is a little square of blue,
here an oblong of pink,
here a streak of yellow,
and paint it just as it looks to you.

CLAUDE MONET

Color expresses something by itself,
one cannot do without this, one must use it;
that which is beautiful, really beautiful—is also correct.

VINCENT VAN GOGH

The successful painter is continually painting still life.

CHARLES HAWTHORNE

Color studies are the crucial ingredient in the process of learning full-color seeing. A color study is a painting done for the express purpose of studying the effects of light and color. The emphasis is on seeing and painting color, not on complex compositions, or intricate, detailed forms. The purpose of a color study is not to make a finished work of art but simply to practice seeing and painting. Just as musicians practice scales as a foundation for their music, painters do color studies to gain fluency in the language of light and color.

Ahead you will find a detailed description of how to begin a color study, but first a word about materials.

Start with Oil Paints or Soft Pastels

Over the years many artists using many different mediums have studied at the School of Light and Color. While the color approach taught here can be applied to any medium—such as watercolor, acrylics or colored pencils—it is most quickly and easily learned using an opaque medium, such as oil paints or soft pastels. Once the artist has grasped the basics, s/he can then translate this approach to other mediums.

I use oil paints because of their flexibility (colors can be altered easily and rapidly) and for the range of colors they offer. However, some people prefer the convenience and ease of soft pastels.

BENEFITS OF USING OIL PAINTS:

1. The colors are rich and pure. They can easily be mixed to get light, dark, or dull colors.

2. The medium stays wet for a long time. You can mix the colors directly on your canvas without the paint becoming too tacky or dry (as can occur with acrylics).

3. You can apply the color in successive layers without getting too muddy (as can occur in watercolors).

4. Oils are the most forgiving medium. You can scrape off color, add as many layers as you wish, blend, and use a variety of techniques.

BENEFITS OF USING SOFT PASTELS:

1. Soft pastels have hundreds of bright, rich colors. Less mixing is needed.

2. Pastels easily cover underlying colors (which isn't easily achieved with colored pencils). Layering can also be accomplished without blending, so the underlying colors can show through as desired.

3. Although there's skill involved in learning how to layer pastels, they require less dexterity than oil paints applied with a palette knife.

4. Pastels are very easy to travel with.

5. Pastel paintings can be easily reworked.

Supplies for Oil Painters

PAINTS:

Any good-quality brand of oil paints will do: Winsor & Newton, Holbein, Gamblin, Grumbacher, Sennelier, Old Holland, Rembrandt and others.

A BASIC COLOR PALETTE:

The basic colors I recommend for a palette are: titanium white, cadmium lemon, cadmium yellow, cadmium red, permanent rose, permanent magenta, dioxizine purple, ultramarine blue, cobalt blue, cerulean blue and viridian green. This is a good palette to begin full-color seeing and painting.

Here are some additional colors you may want to use later on: cadmium yellow deep, cadmium orange, bright red, cadmium scarlet, permanent mauve, cadmium green pale, Indian yellow, and yellow ochre pale.

This palette includes a full range of warm and cool colors as well as bright and deep colors. Generally, warm colors are yellows, oranges, reds, and pinks and cool colors are blues, greens, violets

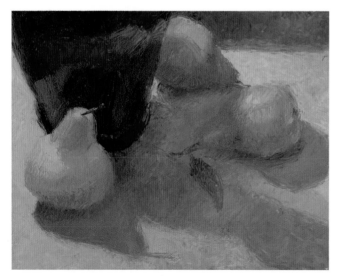

Cobalt and Pears, oil, 11 x 14 inches, Susan Sarback.

and purples. Of course, in a painting the warmth or coolness of a color is largely determined by the colors surrounding it; a yellow-green looks cool next to orange and warm next to blue. Colors are always relative to each other.

Most of the colors on this palette have a cooler version and a warmer version. For example, lemon yellow is cooler than cadmium yellow, ultramarine blue is cooler than cerulean blue, and permanent rose is cooler than cadmium red.

I do not include black on my palette as it deadens the colors. You can achieve deeper, richer colors without black, by mixing from the colors on this palette.

Experiment and practice mixing colors. Any given color can be mixed in a multitude of ways, so I stay away from giving formulas in order to encourage students to respond with freshness to the colors they see in their subject.

SETTING UP YOUR PALETTE:

Arrange the colors on your palette in the order of the spectrum, keeping the warm colors on one side and the cool colors on the other. I use a small palette and rest it on my easel, because I like to have both my hands free.

PAINTING SURFACES:

I generally paint on a hard surface. I use either gessoed masonite (hardboard) panels or canvas-covered hardboard panels. When using a palette knife, it is better to work on a hard surface than on stretched canvas. In addition, when painting outside, it's much easier to work on a hard surface that does not let light through, as a stretched canvas would.

You can make your own painting surfaces, if you wish, or purchase prepared canvas panels from art vendors.

To make your own gessoed masonite panels, first cut them to size. If the size is under 12" x 16", use 1/8" thick panels. If it is over 12" x 16", use 1/4" thick panels.

Lightly sand the panels, then use two coats of gesso. I use Liquitex gesso but other brands may work as well. Sand between coats.

THE ADVANTAGES OF USING A PALETTE KNIFE:

When I first studied light and color, I was taught to paint with a palette knife, also called a painting knife, rather than a brush—and for good reason. When students start with brushes, they tend to fuss with details. The knife forces them to paint in the larger, simpler masses most appropriate for learning color.

Brushes, unlike palette knives, require the use of a medium. Keeping brushes clean from color to color is difficult because the previous color mixes with turpentine or other mediums and stays in the bristles of the brush. Keeping a knife clean is easy. You just wipe it off with a paper towel between colors. Since no medium is required, the colors on the palette stay pure and the painter is exposed to less toxicity.

If you paint with a palette knife, make sure it is fairly flexible. Use the side of the blade, not just the tip, to apply paint. Don't dab or poke the paint onto your board; spread it on as though you were buttering toast. Experiment to find the methods you like best.

It may seem awkward at first, but with practice the knife becomes a pliant painterly tool. As you become more adept at the process of full-color seeing and painting, any tool (including brushes on canvas) can be used. I still use a palette knife most of the time, because I like its convenience and the clarity of color it affords.

Palette knives come in a variety of shapes and sizes, but no matter which you choose be sure the blade is flexible. My favorite knife is the Holbein SX Series palette knife. It is stainless steel, supple and long lasting. Holbein palette knives come in an assortment of sizes. The #2 palette knife is one of my favorites. Other brands of palette knives, such as Loew-Cornell or Langnickel, also work well.

RESOURCES:

There are several art catalogs that offer quality supplies at discount prices. Here are a few:

Cheap Joe's, (800-227-2788), www.cheapjoes.com
Jerry's Artarama, (800-827-8478), www.jerrysartarama.com
ASW, (800-995-6778), www.asw.com
Dick Blick, (800-828-4548), www.dickblick.com
Art Express, (800-535-5908), www.artexpress.com
(for Holbein palette knives).

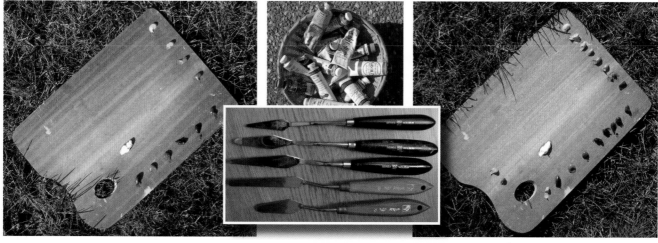

Basic Oil Paint Palette *Palette Knives* *Expanded Oil Paint Palette*

Supplies for Soft Pastel Artists

Soft pastels are essentially the same pigment as oil paints but without any carrier i.e. oil. They are molded by hand or machine into sticks, sometimes using a binder. They are very pure in color, are easy to use, do not fade or yellow, and come in hundreds of hues. As with oil painting, learning the techniques involved in applying and layering pastels requires some time and practice.

TYPES OF PASTELS:

Soft pastels are not the same as oil pastels, and they come in different degrees of hardness. Experienced pastelists usually have

Simple Study of Orange, soft pastel, 9 x 12 inches.

hard, medium and soft pastels in their trays, as each has its purpose. The hardest pastels are brands such as Nu-Pastel or Goldfaber student grade. These are often less expensive than other pastels and don't rub in or spread as easily. The softest (and usually most expensive) pastels, such Unison, Sennelier, Grumbacher, and Great American brands, spread most easily and are often used for more advanced work. All-around pastels of medium hardness, such as Rembrandt or Windsor & Newton brands, are the best choice when learning.

A BASIC COLOR PALETTE:

Here's a basic beginning set of pastels that you can create for yourself. Rembrandt colors and numbers are listed, but other brands may be substituted. This set includes a light, medium and dark value for each color, unlike many boxed sets which tend to offer a multitude of different colors but only in medium shades. It is important to have a range of values in your palette or your paintings will lack depth and interest. As with oil painting, it is also important to have a full range of warm and cool colors as well as bright and deep colors.

Ultramarine Blue	506.5	506.7	506.9
Turquoise Blue	522.3	522.5	522.8
Blue Violet	548.3	548.5	548.8
Red Violet	546.3	546.5	546.8
Madder Lake Deep	331.5	331.7	331.9 or 331.10
Carmine	318.5	318.8	318.11
Permanent Red Deep	371.3	371.5	371.8
Orange	235.3	235.5	235.7
Lemon Yellow	205.3	205.5	205.9
Deep Yellow	202.5	205.7	202.9
Cinnabar Green Light	626.5	626.7	626.10
Cinnabar Green Deep	627.5	627.7	627.10

Pastels

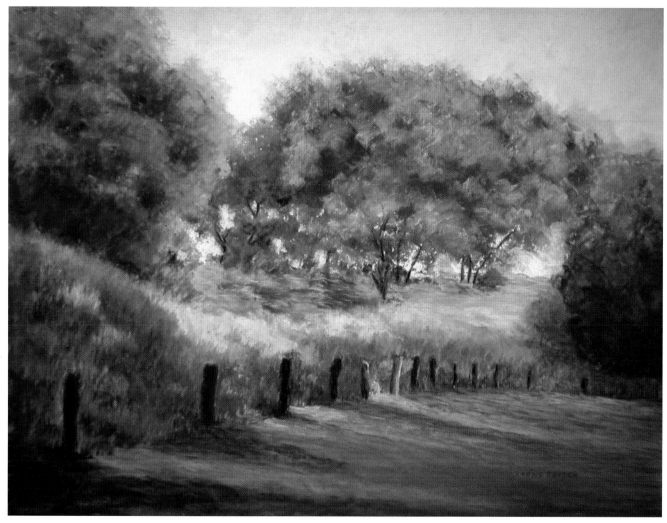

Long Shadows, soft pastel, 18 x 14 inches, Irene Lester.

This pastel painting shows how the full-color approach applies just as easily to pastels as to oils. A wide range of soft and hard pastels on Wallis sanded paper was used to create this striking painting. Notice the variety of warm and cool spectral colors. No browns or blacks were used.

SETTING UP YOUR PASTEL PALETTE:

Separate the cool colors and warm colors: the greens, blues, indigos, purples and violets go on one side of your tray or box, and the reds, oranges, yellows, and pinks go on the other side. If you do this before you start your color study it will be easier to train your eye to choose the color you are seeing.

Set aside any browns, blacks and grays you may have. Browns and grays will appear richer if you create them by layering pure colors.

PASTEL SURFACES:

Beginners to this method often use an all-purpose lightly toothed pastel paper, such as Canson Mi-Teintes. Be sure to choose white or ivory. The underlying color has a strong effect on the color relationships that you are creating. Don't try learning this method on the colored backgrounds recommended in many pastel magazines and painting classes.

As you get more advanced, you may want to use one of the sanded pastel papers, such as Ersta, Wallis, or Art Spectrum Colourfix. Or you might try one of the pastel boards, such as Ampersand Pastelbord, which are hard panels coated with fine granular materials like clay and marble dust. Sanded paper and pastel boards hold many more layers of color than lightly toothed paper.

RESOURCES:

Two good resources for pastel painting supplies are:
Dakota Art Pastels, 1-888-345-0067, www.dakotapastels.com
Dick Blick, (800-828-4548), www.dickblick.com.
For more suppliers see Resources for oil painters, above.

Color Studies—
Begin with Blocks

BEGINNING WITH BLOCKS

Traditional painting classes often use colored wooden blocks to teach beginning students how to see simple value differences; e.g., an orange block appears to be light orange in the light plane and darker orange in the shadow area. But full-color seeing reveals color differences, as well as value differences. An orange block isn't just different shades of orange. It may be yellow in sunlight and violet in shadow. When students first begin to perceive these color differences the effect is often profound.

I use colored blocks to help my students see flat masses of color planes without being distracted by complex forms and color patterns. Later, they advance to rounded objects, more complex still lifes and landscapes.

GETTING SET UP

To begin a color study, set up a still life of blocks or other simple objects lit to create cast shadows. As a beginner, avoid the challenge of patterned surfaces and glossy, reflective objects. Don't worry if your subject seems uninteresting; your real subject is light and color, which is always surprising and beautiful.

Use objects that have a matte finish. You can collect vases, bottles, and other objects and make them into appropriate subjects by coating them with different colors of acrylic paint mixed with gesso. If you want to use fruit, choose ones that aren't too shiny—oranges, lemons, or apples, not cherries or grapes.

Make sure your still life has a variety of colors: red, yellow, green, blue, etc. Choose colors that are both bright and dull, light and dark, warm and cool. For example, you could use a red apple (bright and warm) and a white plate (light) on a blue cloth (cool). Or you might choose a white vase (light) and two lemons (bright and warm) on a green cloth (cool).

For the best composition, use an odd number of objects in your set-up. Three or five are more interesting than two or four.

Make sure your objects are lit from the side or back. Don't light from the front. This creates no shadows, and cast shadows are often the most interesting things to paint in a still life.

Indoors, use halogen lights to get as close as possible to full-spectrum color, or work next to a window. My students often paint outdoors under natural light to take advantage of the most favorable conditions for seeing full-spectrum color. If you're working outdoors, you can try creating different paintings under various weather conditions—sunny, hazy, cloudy, etc.

SKETCHING YOUR COMPOSITION

When your set-up is ready, quickly sketch your composition onto your canvas, gessoed panel, or pastel paper. For color studies it is best to use a small painting surface, usually no larger than 11"x 14". This makes it easier to modify colors quickly.

Don't do a detailed drawing; see your composition in terms of a few simple, large forms. These are the major color masses of your painting. If an object, such as an apple, is half in shadow and half in light, break it down into no more than two different color masses— one for the shadow area and one for the light area. If the object is entirely in shadow or entirely in light, draw it as only one color mass.

Over 50% of your composition should be in shadow. Light appears dominant over shadow. If your painting has 50% of the masses in the light and 50% in the shadow, your painting will appear to be mostly in light. The painting will look balanced if there are more shadow masses than light masses.

In planning your composition remember that no matter how many details are added later, the underlying strength of a work is in the color and value relationships of the major masses. Their structure supports the entire painting.

For an example of a composition sketch see page 39.

Simple Block Study, oil, 11 x 14 inches, Susan Sarback.

Painting colored blocks is the best way to understand color relationships on flat planes. These blocks are brightly colored on a light, cool table top with a dark background in shadow. This was painted outdoors on a sunny day.

When arranging objects for a still-life study, include:

- simple objects that have a matte finish and are not shiny or reflective.

- a combination of various colored objects with different values and chroma (bright and dull, light and dark, warm and cool).

- an odd number of objects for your composition.

- keep objects side or back lit to create more shadows.

- major areas of both light and shadow.

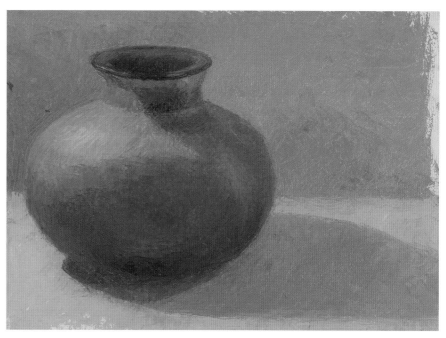

***The Blue Vase**, oil*, 11 x 14 inches, Susan Sarback.

A simple painting of only one subject can still be a good study. This vase of frosted blue glass has a matte finish and is side lit. It has five masses—three are in shadow and two in direct light.

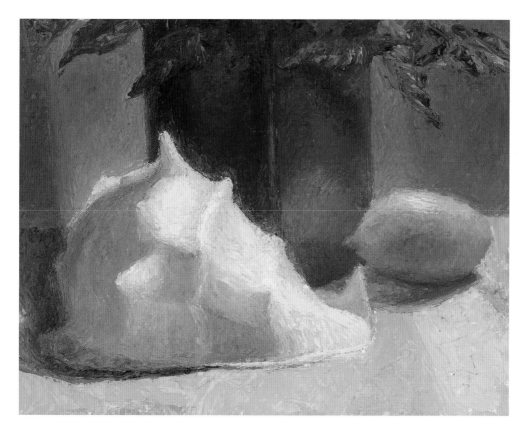

***The Conch Shell**, oil, 11 x 14 inches, Susan Sarback.*

This painting made a great study of light and dark and dull and bright colors. The shadow side is a mixture of spectral colors that create a weaving of subdued cool colors contrasted by the dark rich colors of the vase and the bright colors of the lemon. This painting shows clear distinctions between value (light and dark), temperature (warm and cool), and chroma (bright and dull).

Painting Stage One

I have divided the process of painting into four stages:
1. **Stating the major color masses**
2. **Refining the major masses**
3. **Developing three dimensions with color variations**
4. **Painting more color variations and developing edges**

After you sketch your composition onto your painting surface, you are ready to begin Stage One of your painting by laying in the color of each major mass. First, "scan and compare." Moving your eyes over the set-up and comparing color masses, scan for your initial color perceptions. Instead of looking directly at an object, and seeing only local color, compare the color of the object to the surrounding colors as you scan. The color of each form is revealed through its relationship to all the others. Sometimes a color may flash out like a burst of neon; other times it dawns slowly after repeated comparisons. By scanning and comparing, you are able to see the color of the object as affected by the pervading light.

Make your best approximations of the main color masses of the painting, working quickly enough to have them all initially stated within the first fifteen minutes. Because all the colors influence each other, it's easier to see what you have once they're all stated.

Paint one flat color for each mass. Determine a unique color for each color mass. This helps you see specific color differences and avoid generalization.

If you are working with pastels, use the flat side of the stick and make sure the paper is completely covered (no white showing through). It often helps to rub the surface with a paper towel or cloth to spread the color completely. If you're using sanded

paper, you can also spread the color by brushing each mass with water and let it dry before continuing.

If you are working with oils, don't paint to the edge of the mass; leave unpainted spaces between masses. Since you will be going over the masses several times to improve the color relationships, you don't want to fill in the edges too soon and cause colors of adjacent masses to blend right away. If they blend prematurely, the colors get muddy. This is not important if using soft pastels.

Start the painting with the darkest color mass in the shadow. Then paint the rest of the shadow masses. Compare each shadow, one by one. Which shadow is more blue, purple, violet, or green? Which is lighter or darker? How do these masses differ? Now do the same for the colors in the light. Start with the most obvious warm, bright color. Compare each color in the light plane. Which is more yellow, orange, red or pink? Which is lighter or darker?

For example, for a block study in sunlight, start with the darkest shadow. Say it's the side of the block in shadow. Paint that mass first. Then paint the cast shadow and so on, until all the masses are stated in the shadow areas. Use cool colors only—blue, purple, violet, or green. Use a different color for each mass.

Then paint all the masses in the sunlight. Start with the brightest and most obvious color then paint all the other masses in the light. Use only warm colors—yellow, orange, red or pink. Make sure you paint each mass a different color.

Establish Light and Shadow:

Clearly establish the major pattern of light and shade with your initial color statements. Look for the big, overall pattern. Sunny days will provide the clearest distinction between sun and shade.

In general, as already mentioned, the light plane will be warm colors and the shadows will be cool colors. Of course, as the painting develops, you will notice coolness in the light planes and warmth in the shadows, but for your initial statements, it's important to paint the light planes as warm and the shadows as cool. Remember to use your vision to scan and compare each color. Some light plane areas may actually be deeper (but not cooler) than certain shadow areas.

With full-color seeing, color masses, rather than values or linear drawing, are used to describe form. See and paint the light plane and shadow plane as distinctly different from each other. See the differences as changes in color, not just value. All the color masses in the light plane should give the distinct impression of being sunlit, and all the color masses in the shadow plane should give the impression of being in shadow. After your initial statements of the color masses, you should be able to glance at your painting and see light and shadow.

The demonstrations that follow will give you a general idea of how to proceed from Stage One to Stages Two, Three, and/or Four of a painting. In the next Chapter you will learn about these later stages in much more detail.

Stage One: After my initial sketch, I laid in the major color masses on my gessoed panel. It's a good idea to make every mass a different color, to help you differentiate between the masses. As your vision improves, you will notice that two colors that used to look the same now appear as distinct colors.

Simple Block Study

Basic block studies are the foundation of learning full-color seeing. Block studies need not be painted further than Stage Two or, as in this case, Stage Three. The blocks make it easy to see color in terms of masses and flat planes. This simple block study was painted outdoors on a sunny day, using a red block, a yellow block, and a light blue-green cloth.

I do block studies on relatively small panels, usually 11" x 14". This makes it easier to modify colors quickly.

This photograph shows a set-up with two colored blocks in direct sunlight.

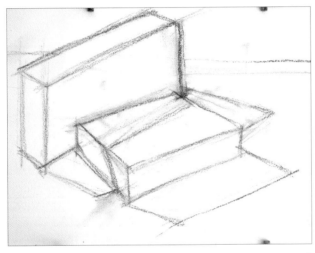

Initial sketch: My initial sketch establishes a simple composition with more than 50% of the subject in shadow. The blocks are relatively large on the canvas so the focus is on the relationship of the color masses.

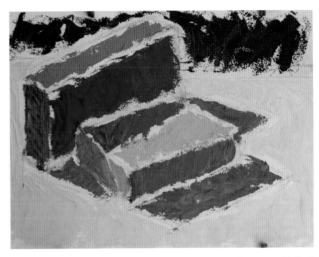

Stage One: Stating the Major Masses. Value (darks and lights) and temperature (warms and cools) are stated for each mass. Each side of a block is a distinct color mass in light or in shadow. The planes in shadow are painted with cool colors and the planes in the light are painted with warm colors.

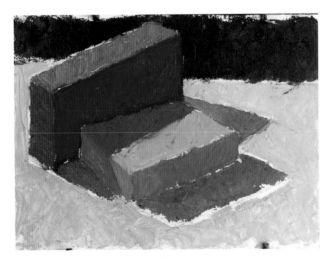

Stage Two: Refining the Major Masses.
I refined the color masses by seeing how they differ from each other. I compared values, temperature, and chroma (bright and dull). For example, I saw that the front of the yellow block, in shadow, was more yellow-green than in Stage One, and that the table top was cooler than in Stage One yet maintained the warmth from the yellow painted in the first stage.

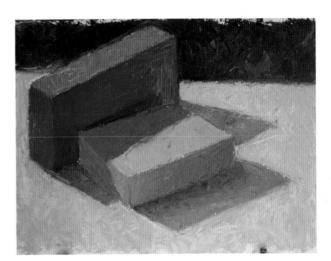

Stage Three: Developing Three Dimensions with Color Variations. In this stage I painted variations in each mass. For example, notice the color distinctions in the shadow side of the red block, and the color variations in the cast shadows.

Soft Pastels — Simple Tree Study

This study of a tree on a sunny day was painted in soft pastels by Irene Lester. Using the same principles as the simple block study, she first saw the tree as simple masses in light and shadow. Notice how the background was also divided into light and shadow.

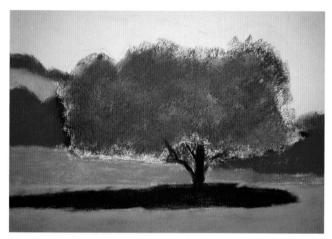

Stage One: Stating the Major Masses.
The masses were simplified into cool colors for the shadows and warm colors in the sunlight. The pastels were applied boldly and blended into the paper to achieve a firm color foundation for the future stages.

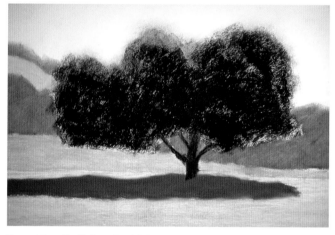

Stage Two: Refining the Major Masses.
Both warm and cool colors were added to these masses to achieve the accurate relationship of colors—value, temperature and chroma. The pastels were applied with layered strokes and less blending.

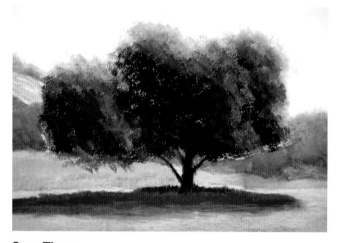

Stage Three:
Developing Three Dimensions with Color Variations.
Notice the diagonal bands of color in the tree and the horizontal bands in its cast shadow. These colors were painted with different types of strokes. In the tree the pastel was applied with small pieces (about one inch wide). The pastel was turned on its side and applied with short strokes in varying directions. In the cast shadow the bands are smoother and painted with long sweeping strokes

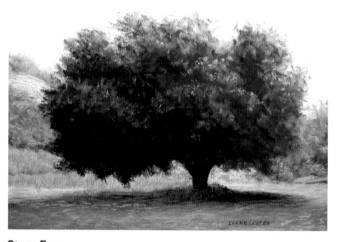

Stage Four:
Painting More Variations and Developing Edges.

The Oak Tree, soft pastel, 8 x 12 inches, Irene Lester.

In the final stage more color variations were created in each of the masses and all the edges were varied. Notice the subtle variations in the distance as well as the bolder variations in the tree. The tree now appears more three dimensional.

Simple Color Studies

For learning purposes, it's best to choose a variety of objects and to paint under a wide range of lighting conditions. To keep your vision and your painting fresh, return to color studies throughout your development as a painter.

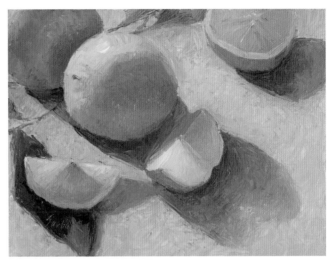

Lemon/Lime, oil, 9 x 12 inches, Susan Sarback.

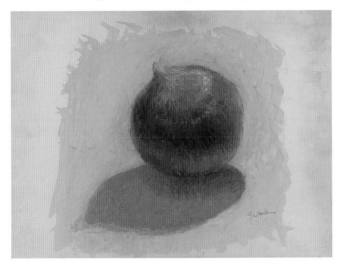

The Red Onion, oil, 11 x 14 inches, Susan Sarback.

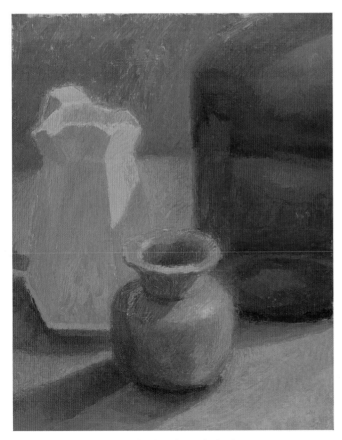

Summer Study, oil, 11 x 14 inches, Susan Sarback.

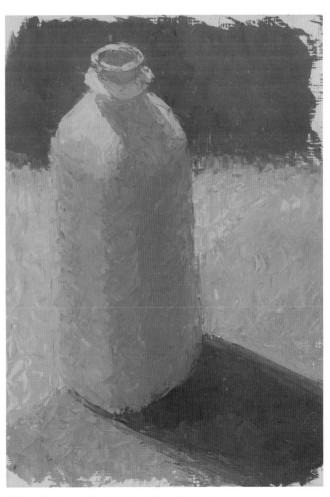

White Bottle, oil, 9 x 14 inches, Susan Sarback.

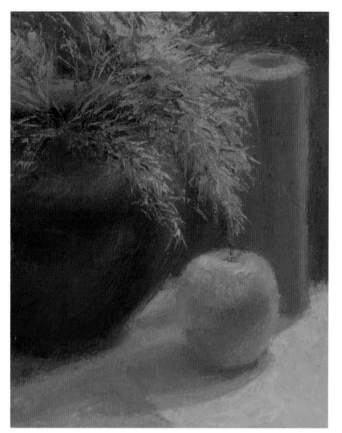

Green Apple, Red Candle, oil, 11 x 14 inches, Susan Sarback.

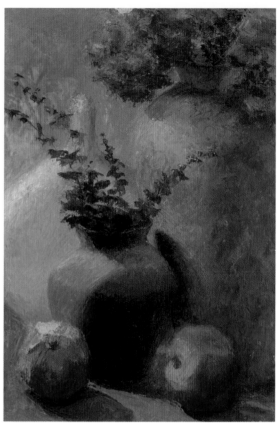

Vases and Pomegranates, oil, 12 x 16 inches, Susan Sarback.

Pondering, oil, 9 x 12 inches, Susan Sarback.

Bowl and Reed, oil, 26 x 42 inches, Susan Sarback.

This is an unusual subject of a hand blown clear glass vase on a window sill painted on a rainy day. There is no artificial light used. On a day like this the cool colors predominate since there is no direct sunlight. Yet notice the wide range of spectral colors, including yellows, oranges and pinks, in the vase and in the reflections on the window sill.

A single reed is seen through both the glass and the water in the vase. Notice the unusual shapes created. They appear quite abstract, but reveal the qualities of water and glass. This is achieved by seeing and painting relative color and shape variations.

Summer Pond, oil, 30 x 48 inches, Susan Sarback.

Chapter Four

Seeing and Painting Radiant Color with Any Subject

Basic order is underlying all life....To study art is to study order,
relative values, to get at the fundamental constructive principles.
It is the great study of the inside, not the outside of nature.

ROBERT HENRI

The subject doesn't matter.
One instant, one aspect of nature is all that is needed....
Nature is a most discerning guide, if one submits oneself completely to it.

CLAUDE MONET

Beauty in art is the delicious notes of color one against the other.
It is just as fine as music, and it is just the same thing,
one tone in relation to another tone....
There are just so many tones in music and just so many colors,
but it's the beautiful combination that makes a masterpiece.

CHARLES HAWTHORNE

Beauty—the adjustment of all parts proportionately
so that one cannot add or subtract or change
without impairing the harmony of the whole.

LEON BATTISTA ALBERTI

It is only through the sense of right relation
that freedom can be obtained.

ROBERT HENRI

Beauty in Color Relationships

One winter morning, I was painting an indoor still life on a windowsill. The painting was about two thirds completed, but it was dull. I tried to improve it, but I knew only tricks and gimmicks, like adding brighter colors or placing complementary colors next to each other.

Nothing worked. Finally, I put my attention back on the color relationships I actually saw. That's when the painting became radiant.

I used to expect that my best paintings would be the ones I'd worked on the most, the ones with the most finishing touches and carefully observed details. A quick study I did as a beginning student proved me wrong. It was only 9 x 12 inches—a small, hazy sunrise painting of a country lane, which I completed in one session. In a few large color patches, I simply indicated the main color relationships I saw.

I didn't paint any details. The light changed quickly as the sun rose, so there was no time for lengthy development. It was only later that I saw the special quality of this little painting: pure freshness and vitality. Its beauty rested solely on the simplicity of the color relationships.

Full-color seeing is the study of light as revealed through color relationships. A painting is made up of shapes and colors. Each is a part of the whole picture. We see the beauty and truth of nature by relating each color to the whole painting and each color to other colors.

The principles of full-color seeing are essential to seeing these color relationships. You need to be relaxed and receptive. Looking directly into a color, or mentally prejudging colors yields mainly local color or a neutral effect.

Seeing color relationships means learning to relate parts to parts and parts to the whole.

In this chapter I will explain Stages Two through Four and explore ways to apply the principles of full-color seeing and painting.

Shadow Brook, oil, 20 x 30 inches, Susan Sarback.

I was looking down at a small brook and noticed a simple yet beautiful painting subject. To create this beauty, I had to realize that the strength of the painting woud lie in the relationships of the large color masses. In this painting there are five major masses, three in shadow and two in light.

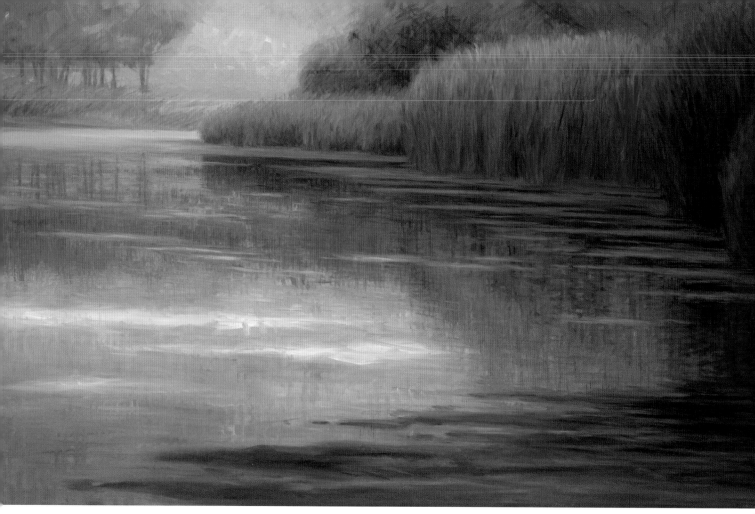

Autumn Pond, oil, 30 x 48 inches, Susan Sarback.

I painted this on a hot sunny autumn morning. The large masses of warm and cool colors created a striking painting subject. Notice that the right side of this painting is mostly in shadow and the left side is mostly in direct light. I cropped out the sky because I wanted the eye to be drawn to the water. The sky reflection in the pond, next to the orange reflection from the hillside, created a dramatic effect.

Sunflowers, oil, 12 x 16 inches, Susan Sarback.

I painted these sunflowers which were set on a windowsill on a cloudy day. I was attracted to the contrast between the bright warm orange of these flowers next to the cool dull colors seen through the window.

High Noon, Late June, oil, 11 x 14 inches, Marilyn Rose.

Painted midday, this high contrast painting shows the richness of colors on a hot summer day in Northern California. Notice how warm the greens appear in the sunlight.

Painting Stage Two

In Stage Two, you relate all the colors to each other. You begin to develop the initial color masses laid down in Stage One. The number of masses remains the same and each mass remains a solid color, but you refine the color relationships by comparing the value (light/dark), temperature (warm/cool) and chroma (bright/dull) of each mass to all the other masses. As you develop these basic color relationships, the structural integrity and light key, or atmosphere, of the painting emerge. (Light key is covered in depth in Chapter 6). For this reason I often say that Stage Two is the most important stage of the painting.

Stage Two—Refining the Major Masses.

Comparing Parts to Parts

Seeing color accurately is not unlike seeing form accurately; everything must be observed in relationship. I remember watching a beginning art student work on a charcoal portrait of a model. He labored intensely on each facial feature, making sure to closely observe the eyes, nose and mouth. But when he finally took a break and stepped back, he saw that his portrait was all wrong; the eyes were too far apart, the nose was too big for the face, and the mouth was too close to the nose. Because he had focused on each part without relating it to the whole and to the other parts, he missed the likeness of his model.

The same principle applies to capturing the effects of light. All of the parts must relate to each other. Through accurate color relationships, the quality of light begins to emerge in a painting.

Comparing a color to other colors, both next to and farther away on the painting, helps you see color relationships. Ask yourself these questions:

• Which color is lighter or darker?
• Which color is warmer or cooler?
• Which color is brighter or duller?

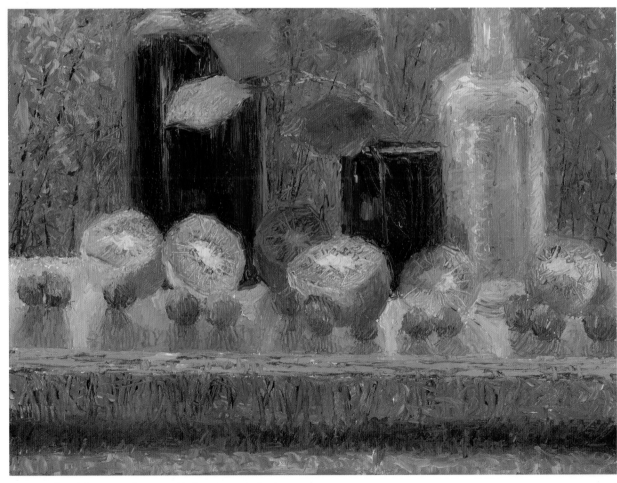

Kiwis and Cranberries, oil, 11 x 16.5 inches, Susan Sarback.

These were painted on an overcast day. They sat on a glass shelf, and the challenge was to see and paint the subtle differences between these green kiwi halves. Notice the cool and warm colors used to show these understated differences.

I may see that a shadow is cooler and deeper than the light plane. By scanning and comparing the shadow to other colors, another shadow, or something in the far distance, I gather information about the color I'm working on. I can determine the specific color it's leaning toward, perhaps a blue, green or violet.

Some relationships will be easier to see than others. It's easier to see the obvious difference between two colors that contrast each other, such as violet and orange, than a subtle difference between two similar colors, such as violet and blue. Suppose I am painting two apples in sunlight casting shadows on a blue cloth. It is easier to see the color difference between the light and shadow sides of the apples than the color difference between the two cast shadows on the blue cloth.

Once I do see the subtle difference between these two colors (perhaps one shadow is bluer, the other more violet), I paint it so that the distinction is evident. Often colors must be painted more obviously than one might imagine, in order for the distinction to be available and clear at a distance.

Comparing Parts to the Whole

Suppose I am painting a landscape with a bush in sunlight and a fence in shadow. To see the color of the bush, I scan the scene, noticing how the bush relates to the whole scene. I sometimes use questions to guide my vision. Is the bush the brightest spot in my view? The darkest? The warmest? The coolest? Of course, most of the colors in a painting will fall somewhere between these extremes.

Late Afternoon, oil, 11 x 14 inches, Susan Sarback.

In this quick study, the bush in sunlight was the brightest part of the painting. To make it stand out, I compared it to the fence, the background bushes, and the shadow of the bush. Every time I changed a color on the fence or the shadow, I had to check the whole painting to see if the relative brightness of the yellow was still intact.

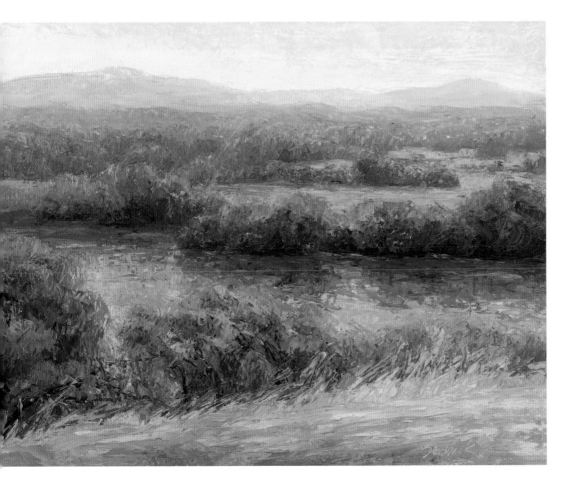

Across the American River, oil, 12 x 16 inches, Susan Sarback.

In this scene the distant trees and hills were distinctly lighter, cooler, and duller than the foreground trees. In order to see this, I had to constantly compare the foreground bright, high-contrast trees to the background. Then I had to paint these differences in order to show how a 20 mile distance can be captured in 12 inches of canvas.

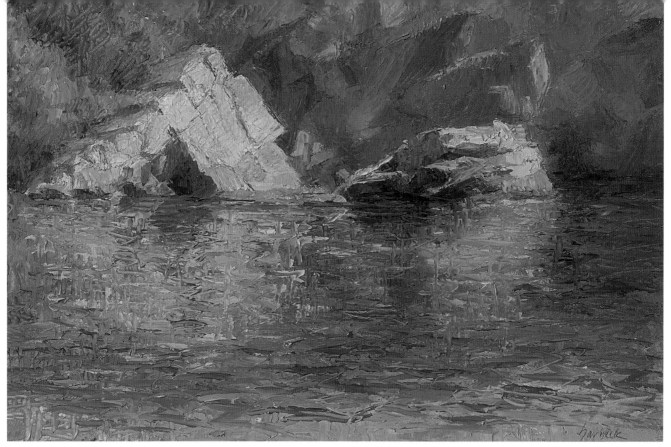

Reflecting Rocks, oil, 12 x 16 inches, Susan Sarback.

To see the color of the rocks and its reflections I compared the rocks to the sky. Even though the sky was not in my painting, I was able to see how bright the rocks in sunlight were in comparison to the lightness of the sky. Then I saw that the reflections in the water were not as bright as the actual rocks. Painters often find that the land has more contrast and brightness of colors than its water reflections.

After I scan the scene, I look at my painting. I may notice that the actual bush seems to stand out with its warmth and brightness, whereas the bush in my painting seems to blend into the fence in the background. My first impulse may be to change the color of the bush. However, since the light effect is a result of the interrelationship of all the colors, I also need to check the other surrounding colors.

It may be that the color of the bush is fine, but the shadow of the fence needs be modified—made cooler or less neutral. This can only be determined by scanning and making repeated comparisons. With practice, it becomes a habit to see color relationships; it feels more natural and less analytical.

One way to gain perspective on the whole is to look entirely outside the view you are painting. By comparing dark colors to a black object, such as the handle of a painting knife, it is often easier to gauge the correct degree of value (dark to light). Similarly, light colors can be compared to a pure white object.

This technique of looking outside the scene being painted can also be applied to seeing specific hues of color. If I'm painting a still life with a shadow that looks blue, I may compare it to the bright blue sky overhead. I often advise students to look away from their still life set-ups as an aid to seeing color.

Students sometimes labor exclusively on an individual color, or on a specific area of a painting, trying to get it exactly correct before moving on to another area. But accurate color relationships do not result from a single-minded focus on getting it right the first time or on perfecting a single color. Accurate color emerges out of a process of continual refinement of all the color masses in the painting.

Let's take the example of a student working on the color of the cast shadow of a backlit white vase on an orange cloth. The shadow is an indeterminate blue violet color. The student paints it first blue, then more purplish then adds green, then blue, but nothing seems right. Finally, she turns her attention to the adjacent colors of the vase and the drop cloth, adjusting each slightly as she rescans her set-up. The vase needs a bit of blue, and she adds yellow and orange to the cloth. Suddenly the shadow looks better! No matter how long she labored over it, she couldn't improve the shadow until she addressed other colors on the painting.

A painting is developed as a whole, not section by section. Each color change will have an impact on all the other colors in the painting. Sometimes these effects are imperceptible, sometimes evident. Continual modification of all the colors slowly refines the color relationships and develops the painting as an organic whole.

In this process of adjusting the colors, we begin by stating the obvious and then move toward subtlety. The initial boldness and vigor of the large solid color masses created in Stages One and Two lend strength to a painting, which in a sense stays with it as the color relationships are developed and refined more and more in the later stages.

Refining the Major Masses

Because the color relationships of the major masses are the foundation of a painting, it's important to see them accurately. The right relation of the masses creates the integrity of a painting. Take as much time as needed to refine these relationships.

Work by making comparisons, improving the initial color statements laid down in Stage One as you see the colors better. Continue scanning, comparing each mass to all the others and checking it against the whole. Rather than trying to mix the exact color on your palette or pastel paper, think more in terms of what color needs to be added to what already exists on the canvas.

Suppose you scan and see violet in a shadow mass, and you have blue already on your canvas. If your paint is still wet, you may simply add red to the mass on your canvas, since red and blue make violet. For oil painters much of the mixing of the paint is actually done on the painting itself. Each mass will undergo several modifications as you get closer and closer the correct color.

To continue working on an oil painting that has already dried, I scrape the surface with my palette knife to remove ridges and bumps and regain the smooth surface I need to continue painting. Otherwise, the surface gets too uneven to work on easily. When I paint wet-on-dry, I sometimes let the underlying color show through to varying degrees. Other times, I begin by restating the area of color that needs work.

If you are working in pastels, you would create the violet by simply layering strokes of red over the blue, not blending the two colors but letting the blue shine through the red. After adding a bit of red, scan again and check your painting to see if the change made the color more accurate. Until a color is seen in relation to all the rest of the colors of a painting, it is difficult to determine its accuracy.

There are very few bull's-eyes in this way of seeing and painting. Only by looking, trying the color you see, and looking again will you know for sure. It is a constant process of adjusting each color in different directions until the right relationships are struck.

Continue the process of comparing masses—lighter or darker, warmer or cooler—until the relationships on your canvas are as close as possible to the relationships you see. All this time, keep your eyes in motion, blinking, scanning, comparing and staying relaxed and receptive enough to see the color relationships. The colors you see in this way will often be more radiant, luminous and fleeting than the obvious local colors.

You may change the masses five or six times before being satisfied with the accuracy of the color relationships. Even though I sometimes use words like accurate and correct in describing this way of painting, these terms are relative to each painter's development. For beginner and professional alike, there is always another step in the refinement of color perception.

Shadowed Wall, oil, 20 x 30 inches, Susan Sarback.
Two thirds of this painting is of the tree shadow on the wall. Notice the bands of bright and dull colors that exist within this cool shadow. These bands create the illusion of movement within the shadow as if the tree was swaying in the wind.

Painting Stage Three

Now that you have developed and refined the color relations among the large solid masses, you are ready for the next step: working on the color variations within each mass. In Stage Three, the forms in the painting begin to articulate, and depth and dimensionality begin to appear.

Variations within a Mass

The nature of light is revealed in a prism or a rainbow, where the full spectrum of color appears in bands. Such bands of color, in much subtler and more limited ranges, exist on all forms and planes and through them we visually perceive three dimensionality.

Look closely at any object in nature and you will see that within its main color there are many variations. These variations may be obvious or very muted and delicate. By using the techniques of scanning and comparing, you can begin to see the color variations or bands with more and more acuity. For example, in the shadow side of a block, you may at first notice that one side is warmer than the other. The cast shadow may be a deep violet closer to the block, and a lighter blue closer to the edges; the ground cloth may vary from one side to the other.

Even though you may see a number of very small divisions in a mass, it's best to hold back and paint only the major bands of color first. Once, as a student, I was studying the color variations within the shadow side of a large clay urn. I saw perhaps a dozen different colors within that single color mass. I got very excited, as I had never seen such a variety of color. I immediately painted these different colors on my painting for each variation I saw. An advanced painter came by and told me that I had jumped ahead of myself. I needed to get the major variations before breaking the mass into lots of little pieces. This way you maintain the light key (quality of light) and the strength of the form.

Stage Three—Developing Three Dimensions with Color Variations.

Based on what you see, divide the mass into two, three, or four different color variations or bands. It's usually easiest to see these bands in the shadow masses first, so begin there. When these are as accurate as you can manage, paint the variations of the masses in light.

One challenge in stating the variations within a mass is to make them clear enough to be evident, but not so extreme that the integrity of the form is destroyed. Even though the color may shift across the side of a block we still want it to read as a flat plane. If the variations are too exaggerated, it will no longer look like a block; make them too subtle, and they will be lost to the viewer.

Keep in mind that at close range the distinctions we make are more easily seen than when we view the same painting from across the room. For this reason, it is a good idea to frequently step back away from your painting and view it from a distance.

Rounded Objects

Instead of using value differences such as shading and highlights to create roundness, simply observe the color variations that naturally make the object appear round. Observe a rounded object as you would a block. No matter how complex the subject matter, the basic process of seeing and painting is the same. See the rounded object in a few main masses and look for the color bands and the color and shape patterns that are created as the light falls across the form. Every color has a specific shape; paint this shape, not just dabs of color.

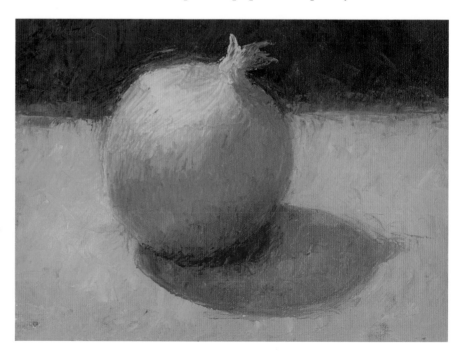

The White Onion, oil, 11 x 14 inches, Susan Sarback.

This simple study shows how the bands of color within each mass create three dimensions. Notice the major bands of different colors in the shadow side of the onion, and in the light plane of the onion, as well as in the cast shadow. These distinct differences help create the volume of the onion as well as the illusion of the cast shadow.

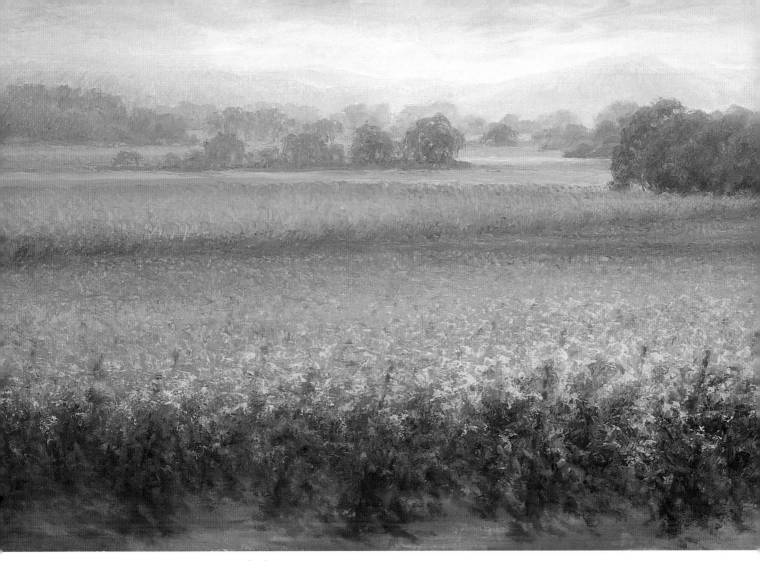

Vineyard Haze, oil, 20 x 30 inches, Susan Sarback.

Notice the bands of color moving back in space. This creates the illusion of the recessional plane of these vineyards. The brighter colors are up front while the bands in the distance get cooler, lighter, and duller. This helps create the sense of space, creating the illusion of great distance.

Flat Planes

Color changes occur on flat planes as well as on three dimensional forms. You will eventually be able to perceive color changes on planes viewed from front to back (recessional planes), and on planes viewed horizontally, from side to side. These are usually more difficult distinctions to see, but with practice they will become more obvious. For example, a tablecloth in a still life would have both of these kinds of color changes, horizontal and recessional. One side of a pink cloth may be slightly more orange than the other, and the back of the cloth may be slightly cooler than the front. Often, recessional colors will be easier to see with distance or under certain weather conditions. A short, recessional plane, like that of a tablecloth, often has subtler changes than the longer recessional plane of a meadow.

Let the Details Take Care of Themselves

Students usually want to paint details first. This is like trying to frame windows before laying the foundation, or putting on makeup before showering. For example, when painting buildings, beginners tend to immediately note architectural details, such as doors and windows. This will quickly establish the image as a house, but it does not help in capturing a light effect.

Don't concentrate on describing details. As you work with more color variations within a mass, the variations themselves create the details. Be concerned first with getting the correct color divisions and relationships. By seeing the details simply as increasingly smaller variations within a mass, you make the painting out of light and color rather than out of a description of the physical subject.

With full-color seeing, attention is on the nature of light revealed as it falls on physical form. A realistic likeness occurs naturally as you paint the smaller color variations within each mass. These variations of color build the forms in your painting.

Painting Stage Four

In Stage Four you complete the painting by determining the final color variations and adjusting all the edges.

The Importance of Varied Edges

To create atmosphere, dimension and space, rhythm and movement in your paintings, you need to vary the edges. If a painter uses only sharp, hard edges everywhere, the image will flatten because hard edges are graphic in nature. They stop the sense of movement, depth and space.

Keep in mind that there are three basic kinds of edges: hard, soft, and lost.

HARD EDGES

At or near the focal point in your painting, use a sharp edge with high value contrast (light/dark) and/or temperature contrast (warm/cool). This brings immediate attention to that area of the painting.

Sharp edges can be used in other areas of the painting if the adjacent masses are similar in value, so the viewer's attention is not drawn to those edges.

SOFT EDGES

There are four kinds of soft edges: diffused edges, broken edges, penumbras and halation.

Diffused edges are soft edges that often slightly blend adjacent colors. They are used so the viewer's eye does not focus on the edge of the subject but sees the light, space or movement around a subject. Diffused edges allow transition from one area to the next. These edges are usually not at the focal point.

Broken edges are not straight lines but a variety of broken strokes. Broken edges are often seen around plant life or large bodies of water.

Penumbras are partial shadows that exist between regions of complete shadow and complete illumination. These are often seen at the far edges of the cast shadows of any subject and sometimes appear as a "double edge." Penumbral edges help distinguish cast shadows from solid objects.

Halation is an effect of light which causes a subtle halo to appear around a light or bright object positioned against a dark background. Halation is produced by the fanlike patterns of light reflected off of the object and onto the background. Putting halation around bright objects creates three dimensionality, whereas painting sharp edges on such objects flattens them.

LOST EDGES

Lost edges are those that cannot easily be observed between forms. They create a sense of distance, fog, haze, or mist. The painter makes a lost edge by either blending colors so there is no sharp distinction between them or by placing colors with the same value side by side.

EXAMPLES

Types of Edges

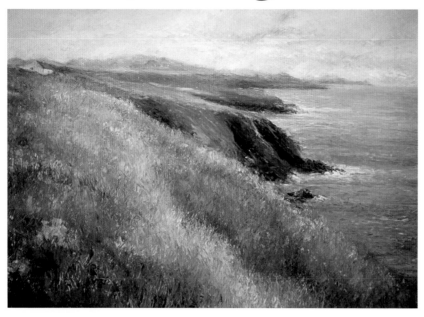

Dingle Peninsula, oil, 16 x 20 inches, Rhonda Egan.
Hard Edges: Seen at the dark cliffs edges (the focal point)

White Statue, detail, oil, Susan Sarback.
Halation: Seen around the edge of the statue

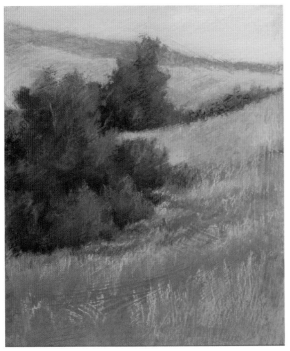

Foothill Shadows, soft pastel, 10 x 12 inches, Marianne Post
Broken Edges: Seen throughout the grass and trees

The Marble, detail, oil, Susan Sarback.
Penumbra: Seen at the edge of the cast shadow

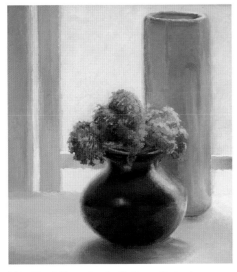

The Black Vase, detail, oil, Susan Sarback.
Varied Edges: This is an example of a few different types of edges: broken, diffused, penumbra.

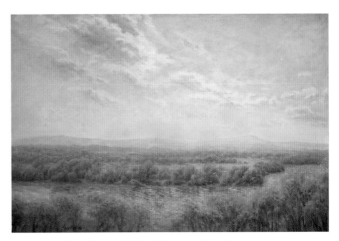

American River Vista, oil, 24 x 36 inches, Susan Sarback.
Diffused Edges: Seen in the distant hills and the clouds

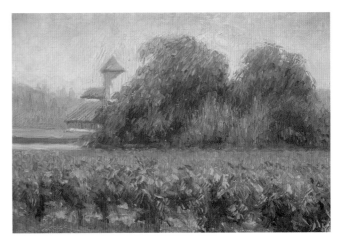

Vineyard Morning, oil, 9 x 12 inches, Susan Sarback.
Broken Edges: Seen throughout the vineyards

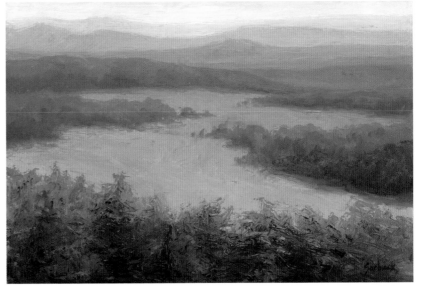

Valley Vista, oil, 12 x 16 inches, Susan Sarback.
Lost Edges: Seen at the edges of the distant mountains

Painting Reflective Light

Most of the time, but not always, reflective light reflects into the shadow. Start by painting the shadow and reflective light as a single shadow mass. Later, create the reflection by painting the reflective color on top of the shadow area.

Make sure that you paint the reflective light as darker than the light it is reflecting. For example, if you're painting a blue vase on a yellow tablecloth, the yellow may be reflecting into the blue vase but it cannot be equal to or brighter than the yellow tablecloth.

Seeing Finer Distinctions in the Color Variations

When working with color variations in a mass, you will see finer and finer color distinctions as you move into Stage Four.

The painter Henry Hensche once analogized that just as every good musician knows that each note is distinct, every good painter knows that each color note is distinct. "The lazy painter slurs," he said. "Every shape change is a color change."

Each of the variations within a mass can be seen as specific shapes with distinct colors. These colors are clearly visible if you look for them. Hensche said:

> *The fascination of this study of visual life lies in the fact that there is no repetition of any color combination.... When you find a duplication of any color in any area, it means you have not perceived the difference and could not separate two color notes that are close together.*

In your color studies, you will explore making finer and finer variations. Later, as you become more advanced, you may choose the extent to which you wish to make variations within each mass of the painting. Sometimes there is a greater eloquence in simplicity and you will prefer to make fewer variations.

In any case, there should always be more variation near the focal point, and much less variation near the periphery of the painting. The viewer's eye goes toward visual activity (more variations) and you want to draw it toward the focal point.

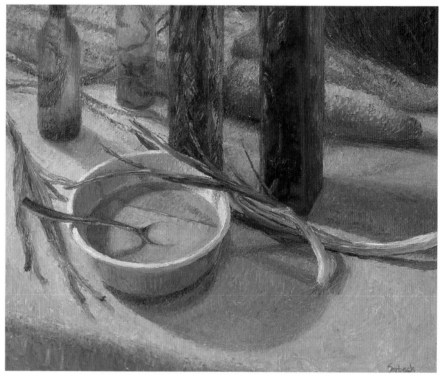

Squash Soup, oil, 20 x 24 inches, Susan Sarback.

Even though this appears to be a painting with detail, there is no detailed description. Instead there are finer and finer color distinctions which appear to create detail. For example, there are many bands of color in the bowl of soup. These distinctions are created by the shadow from the spoon, the green onions, and the movement of light across the surface of the soup. The details are created by the increasingly small variations within the mass. These variations are also seen in the many colors of the cast shadows in this painting.

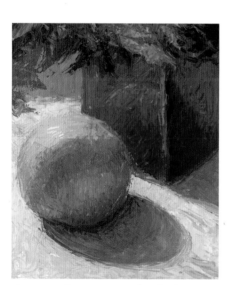

Orange and Square Vase, detail, oil, Susan Sarback.

This is a good example of reflective light. The vase was first painted a cool color because it was in shadow. Then the warmth of the reflection was added. Notice the orange reflection on the dark vase is darker and cooler than the orange itself in full light. Reflective lights are usually darker and duller than the light it is reflecting.

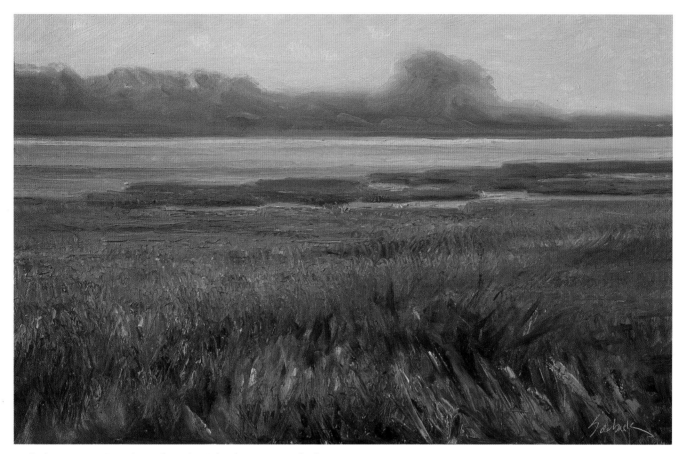

Batiquitos Lagoon, San Diego, oil, 11.5 x 16.5 inches, Susan Sarback.

This painting shows the full spectrum of color as seen on a hazy day. The warm colors in the land (those areas in full light) and the water were painted in Stage One. The water was originally pinks and light yellow and the land was bright oranges and yellows. Notice the bands of warm and cool colors in the field and the coolness of the distant trees. Recession is captured by creating differences in color, the size of objects, and paint strokes.

Summer Pots, oil, 16 x 20 inches, Susan Sarback.

This outdoor study shows how each object has the full spectrum of color yet appears very different. Once you see the color, you will be able to identify how every color differs from and relates to the others. When you see the color variations clearly, you won't paint any of the colors exactly the same. This creates the luminosity seen in each of these objects.

Summary

To review, in this approach to painting, there are four stages which are the same for a beginning study as for an advanced painting. A painting can be complete at any of the four stages. Some artists who are more interested in capturing the color relationships rather than showing three dimensions may stop at Stage Two. Others who are interested in showing how color captures three dimensions, but who are not interested in details or refinement, may feel the painting is complete at Stage Three. The goal is not to reach Stage Four, but to capture a quality of light.

This approach is a direct and conscious way to achieve radiant color in any of your paintings. Since this technique is not random, as you master it you can begin to achieve consistent quality in your work.

The Four Stages — Seeing and Painting Color Variations

This still life includes an orange, which is opaque and round, a couple of orange wedges, angled and flat sided, and a transparent glass bottle. They are painted a bit larger than life size. I chose both warm and cool subjects that are brightly colored and lit them from the side, creating long cast shadows. As with all my paintings, I worked directly from life.

It's a good idea to paint a lot of close-up studies for the purpose of understanding how color creates form. Don't labor over these paintings. It's best to do them quickly and focus on the four-stage process. This will create a strong foundation and a freshness of vision. This painting took about 2 hours to complete, and I paid special attention to the color variations within the major masses.

Initial Sketch: This sketch divides the subject into light and shadow masses. Notice that the orange is divided into two masses—light and shadow.

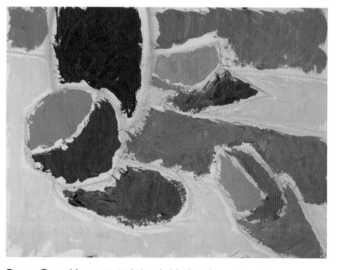

Stage One: After my initial sketch, I laid in the major color masses on my gessoed panel. It's a good idea to make every mass a different color, to help you differentiate between the masses. As your vision improves, you will notice that two colors that used to look the same now appear as distinct colors.

TIPS

Always Ask Yourself...

How do the masses differ from each other?

- Value..Lighter/Darker

- TemperatureWarmer/Cooler

- ChromaBrighter/Duller

One of the greatest things in the world is to train ourselves to see beauty in the commonplace....Discover beauty where others have not found it....The painting of still life gives one the widest range for study – a bottle is as serious a subject...as a person.

– CHARLES HAWTHORNE,
HAWTHORNE ON PAINTING

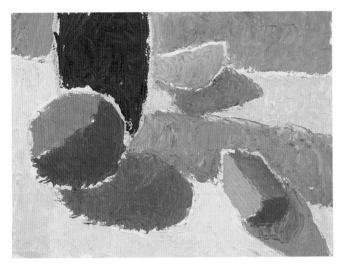

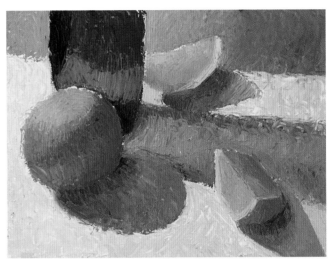

Stage Two: In this step, I refined the masses of color. I made sure to maintain a clear distinction between the light plane and the shadow plane to keep the effect of bright sun. I scanned and compared to see what colors were needed to improve my initial statements. In this stage I was able to add both warm and cool colors to the light and shadow planes. This can be done as long as the shadows remain dominantly cool and the light planes remain dominantly warm.

Stage Three: In this stage I began to paint basic variations of color within each mass. I saw three distinct bands of color in the shadow side of the orange—a darker green, a lighter blue green and a redder violet. These were painted into the foundation that I had established in Stage Two. I had to make sure that, when squinting my eyes, the shadow mass stayed in the shadow. The same holds true for the variation in the light plane of the orange. Also note the variations or bands of color seen in each of the cast shadows, the tabletop, the orange wedges, the bottle and the background.

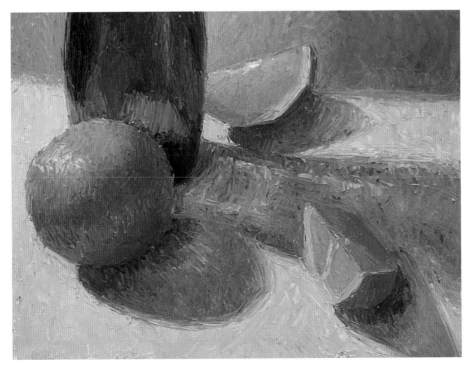

Stage Four: In this stage, the area of focus (the orange) is further developed by painting more color variations. The edges of the orange are relatively sharp compared to the edges of the cast shadows and the tabletop. The eye will tend to focus on the area with the most color development, the area of highest contrast, and the sharpest edge. The eye is attracted to the place where the orange meets the blue bottle. The glass bottle has fewer variations and less contrast. Note that the reflections of the oranges in the blue glass are much darker and duller than the actual oranges. Reflections always appear less vibrant than the object itself.

Cobalt and Orange, oil, 11 x 14 inches, Susan Sarback.

The Four Stages to Radiant Color

STAGE ONE: STATING THE MAJOR MASSES.

Stage one is an underpainting. It sets up the basic structure of the painting and defines the light source. Value and temperature are established (light/dark and warm/cool).

- Divide the composition into large, simple color masses or shapes. Paint each mass a different, single, flat color.
- Begin with the darkest mass, then paint the rest of the masses that are in shadow.
- Paint all the masses in shadow with only cool colors—blue, violet, green and purple.
- When you have completed the shadow masses, paint the masses that are in light.
- Paint all the masses in light with only warm colors—red, pink, yellow and orange.
- Use pure, bright colors in this stage (if you are painting with oils, add white, but never black, to adjust values). Stage One will look over-colored and exaggerated.
- Keep the edges loose (no tight edges). If you are painting with oils, leave a space around each mass or color shape.
- Complete Stage One in fifteen minutes or less.

STAGE TWO: REFINING THE MAJOR MASSES.

Stage Two defines the light key (atmosphere) and establishes the integrity of the painting by developing the relationships of the color masses. This is the most important stage in any painting.

- Do not increase the number of color masses in the painting. Keep each mass a solid color (without variations), distinct from the colors of all the other masses.
- Refine the colors of the masses by seeing how they differ from each other.
- Compare: Value: light/dark
 Temperature: warm/cool
 Chroma: bright/dull
- Mix colors directly onto your painting to create accurate color relationships between the masses. You may mix a warm color into a cool color, a cool into warm, a warm into warm, a cool into cool. There is no formula. See what is needed by comparing the masses.
- Colors become duller or more somber the more they are mixed.
- Bright colors are created by painting:
 1. pure (unmixed) primary and/or secondary colors, i.e., yellow, blue, red, orange, green, violet colors or
 2. by mixing adjacent (analogous) colors, i.e., yellow and orange, blue and green, violet and red, etc.
- The local color (e.g., blue for sky) may be added at this point as needed.
- Step back from your painting and ask yourself if any two masses look the same. If so, look for the more subtle differences: lighter/darker, warmer/cooler, brighter/duller.

STAGE THREE: DEVELOPING THREE DIMENSIONS WITH COLOR VARIATIONS.

In Stage Three, the forms in the painting begin to articulate and depth and dimensionality begin to emerge, as color variations are developed within the masses.

- Look closely at any object in nature and you will see many subtle variations within its main color. These give the object form and dimensionality.
- Based on your observation of these color variations, subdivide each color mass in your painting into two, three, or four bands of color. Do not create any more than four bands at this stage.
- Begin with the shadow masses, where it is usually easiest to see the color bands.
- Each color band within a mass will be similar in value and slightly different in color from the other bands.
- Paint the main color bands with soft edges.
- It's easiest to see these bands by realizing that every plane change is a color change.

STAGE FOUR: PAINTING MORE VARIATIONS AND DEVELOPING EDGES.

Stage Four completes the painting by determining the final variations and adjusting all edges.

- Paint more bands/variations within the masses.
- Develop the focal point more than other areas. The focal point may be in Stage Four while the other areas of the painting may stay in Stage Two or Three.
- Vary edges throughout the painting.
- Have at least three types of edges: hard, soft and lost.
- Highlights may now be added.

Applying the Principles of Full-Color Seeing and Painting

The full-color spectrum is always present in natural light. This is apparent when we see a prism breaking white light into the seven colors of the rainbow. Full-color seeing helps us see the full spectrum of color present everywhere.

This does not mean that colors appear in bands like a rainbow, but a painting done with full-color seeing will often contain all colors of the spectrum. Some paintings may seem to have only a few main colors, but usually the full spectrum is subtly present.

Do not labor excessively over each color; trust your first impressions. As the painter Charles Hawthorne told his students:

> *Perhaps we analyze too much. Try putting down your first impressions more. Do what you see, not what you know. Put down each spot of color truly and sincerely—*

> *remember that it is the large spot of color that tells the story. Make the big note and make it true.*

After you initially state the major masses, you will refine their color relationships before going on to a more detailed level. Again, the painter Charles Hawthorne has invaluable advice:

> *The weight and value of a work of art depends wholly on its big simplicity—we begin and end with the careful study of the great spots in relation to one another. Do the simple thing and do it well. Try to see large, simple spots—do the obvious first.*

The following pages show examples, tips and demonstrations of full-color seeing and painting in practice.

Cloudy Day, White Statue, oil, 12 x 18 inches, Susan Sarback.

Sunny Day, White Statue, oil, 12 x 16 inches, Susan Sarback.

I painted the same white statue on a cloudy day and on a sunny day. This is always a good way to study the quality of light and the full spectrum of color. On a cloudy day everything begins in Stage One as a cool color since every mass is in shadow. On a sunny day there are masses in sunlight (painted warm) and colors in the shadow (painted cool).

In Stage Two, warms and cools may be added to any mass. Notice how the statue on a cloudy day appears colder, yet there are warm colors added in small amounts to the cool colors. Also there are bright blues but duller violets and greens created by mixing warm and cool colors.

The Sunny day statue looks completely different. The areas in light are dominantly warm with pinks, yellows and oranges; and the shadows are dominantly cool colors.

Notice the bands of color in the masses. This creates the illusion of volume. The full spectrum exists in both these paintings, but the proportions of colors are very different in each.

Using Color to Create Light and Build Form

Color both builds form and creates light. Some artists paint solid forms illuminated by a clear source of light, others are interested in dissolving form with light and atmosphere. With full-color seeing you can paint distinct forms, loose atmospheric scenes, or anything in between.

Full-color seeing and painting builds form with masses of color. Instead of describing form with lines and values, forms are built through color variations. This approach differs markedly from tonal painting where color is based on value and local color. With full-color seeing, color (value, temperature, and chroma) is essential from the very first stage.

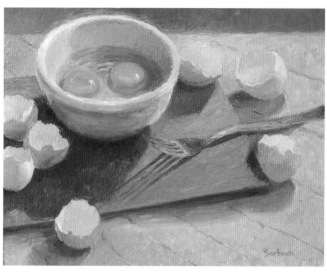

Fork and Eggs, oil, 12 x 16 inches, Susan Sarback.

Here we can see how the range of spectral colors builds the form of these egg shells.

Fair Oaks Bridge, oil, 16 x 24 inches, Susan Sarback.

The colors in the water reflect the bridge, the trees, and the sky. Yet no form is distinct. This shows how color creates movement and a sense of sunlight.

Apples to be Cut, oil, 20 x 24 inches, Susan Sarback.

See how the full range of colors creates the three-dimensional form of these apples as well as the white bowl.

Spring Tulips, oil, 16 x 24 inches, Susan Sarback.

Notice the bands of colors on the tulips and how they create form as well as the subtler colors on the walls that create space.

Tulips and Shell, oil, 12 x 16 inches, Susan Sarback.

The bands of bright and dull colors helps to create the three dimensions of the flowers, the vase and the shell.

Bright and Dull Colors

There are only about twenty bright colors and an infinite number of somber colors. These are not dirty colors, but beautiful spectral colors woven together to create subtle, unusual, unnamable colors. When black and brown pigments are not used, the chance of getting a dirty or dead color is minimal. Most of nature is composed of these somber colors, and there are only a few truly bright colors.

BRIGHT COLORS ARE CREATED BY:

- Using pure primary or secondary colors, e.g., red, yellow, blue, orange, green, purple.
- Mixing adjacent colors, e.g., green and yellow, red and orange, blue and purple.

DULL/SOMBER COLORS ARE MADE BY:

- Mixing warm and cool colors, e.g., green and orange.
- Mixing multiple colors together, e.g., purple, green, and yellow.
- Mixing complementary colors together, e.g., red and green.

WHITE HAS THREE CHARACTERISTICS:

- It lightens, cools, and dulls any color(s) with which it is mixed.

TO BRIGHTEN A WARM COLOR

- Add yellow or orange, e.g., to brighten pink add a touch of orange.
- Surround the bright color with dull cool colors, e.g., to make red look brighter, surround it with a dull green.

TO BRIGHTEN A COOL COLOR

- Use a pure cool color by itself, e.g., blue (the more you mix colors the duller they get).
- Surround the bright color with dull warm colors, e.g., paint a dull orange around a bright blue.

Seeing and Painting the Color of Cast Shadows

Shadows often play a key role in the composition of a painting. If you understand the basics of cast shadows, your paintings will have greater strength and luminosity. Often shadows are just as important as the objects themselves.

This still life is side-lit in order to create long shadows. In studying these shadows, you are studying the same principles that hold true for cast shadows in landscape paintings.

Observe the color of a shadow as if you were observing an object—see it as a mass of color. Look for the color differences between each of the shadow notes. The color of a shadow depends on a variety of factors: the color of the object, the color of the ground, and the pervading light. Scan and compare to accurately see the shadow color in relation to its surroundings. Shadows usually vary in color from the base to the center to the edges. Look for these differences as you paint the color variations.

This study shows three different types of cast shadows: shadows cast from an opaque object, a translucent object, and a transparent object.

- **Shadows cast from opaque objects:** the cast shadow is usually darker nearer the base of the object. It gets lighter as it moves further from the object.
- **Shadows cast from translucent objects:** the cast shadow is usually lighter near the base of the object and darker around the edges.

- **Shadows cast from transparent objects:** the pattern of diffused light seen in this type of cast shadow appears dispersed with no discernable order.

You may see many variations in these three types of cast shadow patterns, but the majority of the time you will see these clear distinctions. Follow these guidelines, but paint what you see. Exceptions to these patterns may create an unexpected freshness.

Initial Setup: This photo shows the setup—shadows cast from a small opaque bowl (foreground), a translucent glass vase (background) and a transparent glass bottle (mid ground).

Initial Sketch

Stage One: I began with the major masses, ignoring details and painting color differences. The shadows began as different cool colors, and the areas in light began as warm colors.

Stage Two: To refine the color masses, I added both warm and cool colors, making sure the shadow areas stayed dominantly cool and the light planes stayed dominantly warm. I painted very simple divisions in the transparent and translucent cast shadow because they were so dominant. I held back on painting the number of variations that I saw. My objective was to see how these shadows differed from one another in color before I painted the details of each shadow.

Stage Three: In this step, I further developed the variations in each of the masses. As the painting developed I kept adding colors into each mass to make it more accurate. I didn't try to mix the exact color I saw; I added color to modify what was already on the canvas. For example, in this stage, I saw the cast shadow of the bowl in the foreground divided into three main bands of color. The darkest band was closest to the bowl and the lightest band furthest from the bowl. The mid-ground transparent bottle cast a shadow that was dispersed and some of this was painted with color and value differences. The background translucent bottle cast a shadow that was lighter in the middle section and darker around the edges. This was painted with more variations than in Stage Two. The background tabletop also had distinct bands of color from front to back and left to right. These were painted in this stage.

Stage Four: In this stage I painted more variations within the cast shadows. I softened the edges of these shadows by painting a lighter band of color around the shadow's edge. This is called a penumbra, which means diffused light. You will see this on all cast shadows. Painting the penumbra helps create the illusion of a cast shadow rather than a solid form.

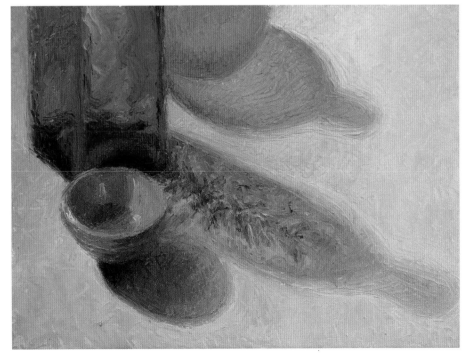

Three Shadows, oil, 9 x 12 inches, Susan Sarback.

Types of Cast Shadows

OPAQUE CAST SHADOWS

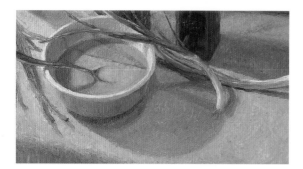

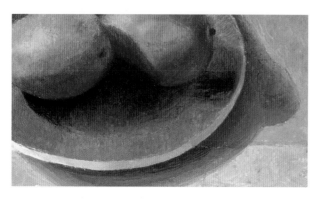

TRANSLUCENT CAST SHADOWS

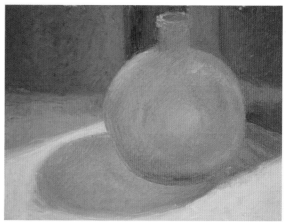

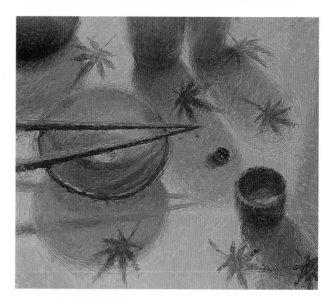

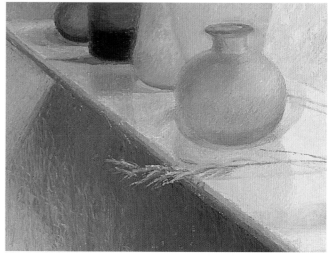

TRANSPARENT CAST SHADOWS

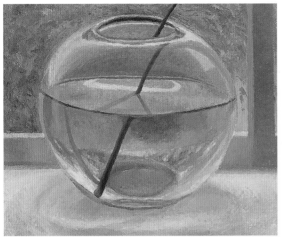

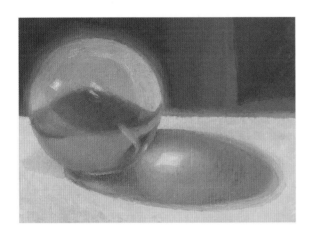

LANDSCAPE CAST SHADOWS

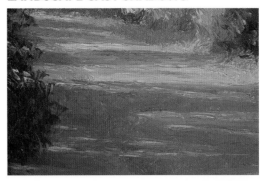

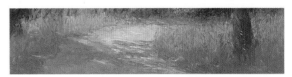

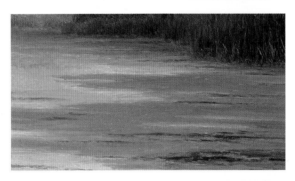

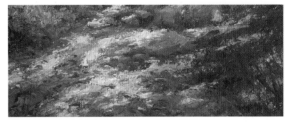

Burney Falls, oil, 16 x 20 inches, Susan Sarback.

Chapter Five

Painting the Landscape with Full-Color

It is not the language of painters
but the language of nature to which one ought to listen.…
I think a painter is happy because he is in harmony
with nature as soon as he can express a little of what he sees.…
The greatest, most powerful imaginations have at the same time
made things directly from nature which strike one dumb.

VINCENT VAN GOGH

Think of color instead of sand—think of color instead of clothes—
color first and house after, not house first and color after.

CHARLES HAWTHORNE

Let color make form—do not make form and color it.

CHARLES HAWTHORNE

It is amusing how little one needs features for likeness—
think of color notes; spots, not planes,
when doing the face out of doors.

CHARLES HAWTHORNE

I remember painting a river scene as a beginning painter. It was a beautiful view and I was very inspired, but it was too difficult for me. I became frustrated and wanted to give up; it seemed too hard. From that experience, I learned to let myself grow step by step. As my vision and skill developed, I gained confidence with increasingly challenging subject matter.

Advanced painters eventually choose complex subject matter, including challenging surfaces to paint, such as water, glass or dappled patterns of light. Or they choose advanced subjects, such as interiors, landscapes and the human figure. Yet, regardless of subject matter, all painting with full-color rests on the same foundation—the color relationships of the masses.

Full-color seeing can be applied to any subject; the principles are the same.

Landscape Painting: Start with Strong Compositions

To capture the essence of a landscape, the painter needs a strong composition. The strength of a composition will attract viewers from across the room. But when they walk up to the painting, they should somehow experience more to keep them there. Color can do this. Color enthralls the imagination and captures the heart.

Composition creates a first attraction; color creates the lasting relationship. A painting needs both. If you create interesting shapes (composition) as well as color, you'll have a strong, successful painting.

How do you create an interesting composition? The key is the spatial relationships of the large, simplified masses established at the beginning of the painting process. The way these masses relate in terms of shape creates an interesting composition—dramatic, tranquil, alive, stable, etc. The way they relate in terms of color—value, temperature, and chroma—creates a depth of interest, mood, and a sense of the quality of light.

To paint a landscape is often overwhelming for the art student because everything looks so complex. To have a strong composition, landscape paintings need to be simplified.

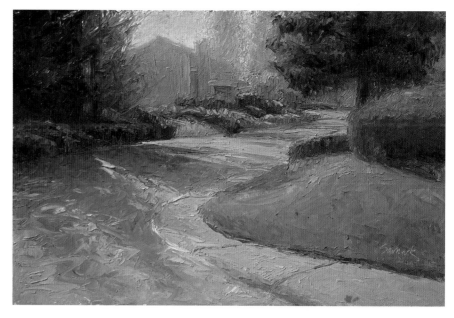

Around the Corner, oil, 11 x 16.5 inches, Susan Sarback.

This dynamic composition is created using several principles of design. 1. Strong diagonal, seen in the angles of the road as well as the cast shadows. 2. A variety of asymmetrical shapes that are distinctly different—note the large area of the road in lower left quadrant of the painting and the smaller shapes in the upper right hand quadrant. 3. Bright high contrast foreground colors vs. subtler less contrasting background.

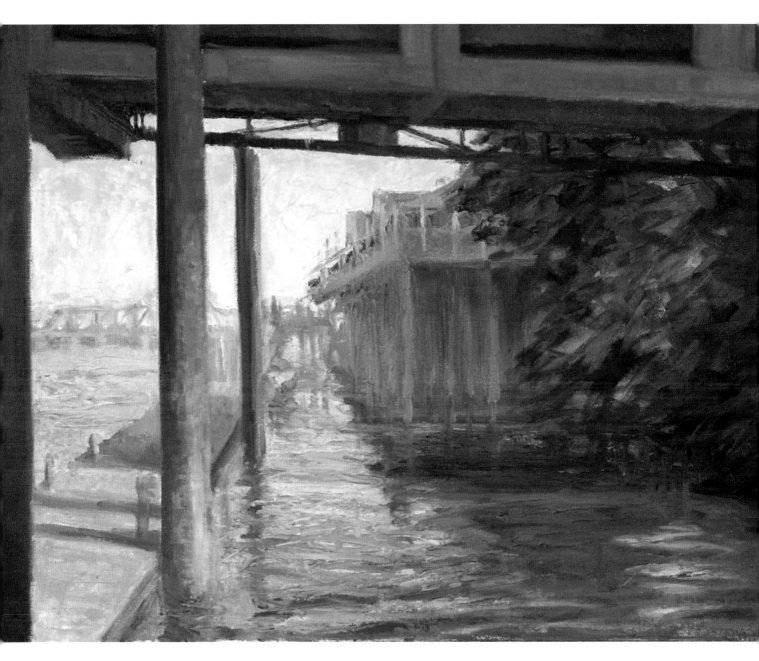

Under the Tower Bridge, oil, 11 x 16 inches, Susan Sarback.

I was walking under a bridge and discovered this unusual scene. The distinct man-made foreground in full shadow is in contrast to the moving water, billowing tree, and atmospheric distance. These contrasts of light and shadow, man-made objects and fluid landscape, foreground distinctness and hazy distance all create an interesting composition without being "picturesque."

Calistoga, oil, 9 x 12 inches, Susan Sarback.

I painted this scene in the late afternoon on a sunny summer day. About 65% of this subject is in full shadow and the light is coming from the back and side. This type of lighting always creates a dramatic effect. Notice how the large shadow masses in the foreground are mostly connected and how light spills over the trees and land creating continuity in the light plane as well. The mountain is lighter and cooler with less contrast because of its distance.

Asilomar, oil, 12 x 18 inches, Rhonda Egan.

A successful painting on a cloudy day is often harder to achieve than on a sunny day. This painting's strength rests with its composition and color. The composition is simple, with a few large interacting masses and a diagonal. A clear distinction between foreground and background is created by value and color contrast. Note that the colors on a cloudy day may not be bright, but they use the full spectrum of color which adds radiance to the painting.

Choosing a Landscape Subject

When you go outdoors to paint, everything can look wonderful. But choosing an intriguing subject is only the first step to creating a strong painting. In fact, a very ordinary subject often makes a beautiful painting, so your scene needn't be picturesque. No matter what the subject, look for interesting lighting, shapes, angles, colors, and patterns.

On sunny or hazy days, where cast shadows are easily observed, try to choose subjects that are side or back lit. Frontal lighting will create few cast shadows, though there are always exceptions to this rule. For example, at sunset or at dawn frontal lighting may create an interesting quality of light.

Generally on a sunny or hazy day, choose a subject that's at least 60 percent in shadow. Light dominates over dark, so a painting with 50 percent in the light and 50 percent in shadow will appear to be mostly in the light. Such a painting may end up looking very warm, very bright, or washed out. With over 60 percent in shadow, the eye can rest with enough cool colors. You may find exceptions to this when painting subjects that have a dominantly cool color. For example, large masses of water—lakes, rivers, and ponds—where you see large areas in sunlight, still have enough coolness on the water (from sky and/or tree reflections) to compensate for a lack of shadow.

On cloudy days, choose subjects with contrast of colors and/or values. For example, bright yellow flowers on a green meadow (warm and cool colors) or dark backlit trees situated in a lighter meadow (dark/light). Remember, if the values of the subject are all similar, the painting will often look flat.

A painting with fewer masses is always stronger than one with many masses. See them as large interacting shapes, and simplify the subject into seven masses or less. Eliminate objects as needed to simplify the composition. Editing is often necessary as you focus on the large masses, not the details. The masses form the strength and integrity of the painting.

Western and Eastern Approaches to Composition

Historically, there have been two main approaches to composition: the Western (European) approach and the Eastern (Asian) approach.

The conventional Western approach uses one-or two-point perspective, a complexity of composition, scenic subject matter, and true-to-life descriptive renderings. The Western artist is often interested in defining a place or subject so literally that there is no question as to where or what it is. For example, a Western painting might show a realistic scenic landscape with a meandering path leading down the road to a distant house.

The Eastern approach traditionally uses atmospheric perspective. This means objects are placed behind other objects to show depth of space and atmosphere. The values get lighter as the objects recede into the distance. You might see this in paintings that show a recession of mountains layered behind one another. In the Eastern approach there's also a simplification of subjects or fragments of subjects, such as part of a tree or waterfall. Eastern compositions are often suggestive rather than descriptive. They catch the essence of a subject with few strokes.

With Eastern atmospheric perspective, the foreground has the highest contrast, the brightest colors, and the most detail and texture. The background is cooler, with fewer details, less texture, and less contrast. Dark colors generally get lighter, bright colors generally get duller as they recede. Finally, trees, buildings, animals, and people all decrease in size as they move back in space.

Napa Valley, Chabot Vineyard, oil 30 x 48, Susan Sarback

This is an example of the Western approach to painting, which is characterized by scenic, realistic subjects and one point perspective leading to a vanishing point in the distance (as seen in the vineyard rows).

San Diego Vista, painting detail, oil, Susan Sarback

This is an example of the Eastern approach to painting, which is less descriptive than the Western approach, uses atmospheric perspective and suggests space with color, value and size. Notice that the highest contrast and brightest color is in the foreground. In the distance the colors are duller, lighter and less contrasting, and objects diminish in size.

Improving Compositon with Thumbnail Sketches

I recommend using thumbnail sketches (not detailed drawings) to help create strong compositions. They only take a few minutes to do and are well worth the time. Begin with these and they will enhance the compositional strength and rhythm of your final painting.

Start with simple landscapes, perhaps a bush next to a house. Then apply the experience gained from doing simple still life studies. Houses are like blocks, bushes are like inverted bowls, and the ground is like the recessional plane of a tabletop.

As always, begin with the major masses, avoiding such details as doorknobs, trellises, berries on bushes, and so on. If the bush is half in shadow and half in light, paint it in two basic colors to begin with, as if it were a bowl, without detailing specific leaves or branches. The house can be painted just as a block would be. As you see the variations within each mass and fine-tune the color relationships, the bush will become more bushlike, and the house will become more houselike.

When moving on to more complex landscapes, it is still best to begin with a simple structure of major color masses. This will make it easier to paint more complicated forms like trees and water without getting lost in the details.

Another compositional "rule" suggests dividing your painting into thirds, like a tic-tac-toe board. The focal point should land at one of the four intersecting points. This creates more interest

Location photograph

than a focal point that's centered or located in one of the corners.

The painter must have a strong composition, but this does not mean following hard and fast rules. For example, I have seen wonderful compositions where the "rule" for locating a focal point is broken.

Learn the principles of good composition, but remember that rules aren't laws. Experiment.

Let's look at the best ways to create thumbnail sketches:

1. Simplify your landscape scene into seven masses or less.

2. Draw the same composition five times without borders. Also, keep the sketches small (2-3" for each one).

3. Place a border around each composition in a different way by cropping parts of the subject.

4. On a sunny day keep over 60% of the composition in shadow.

5. Create interesting negative shapes (the shapes around a subject).

6. Anchor subjects or shadows to the top, sides, or bottom of the composition.

7. Look for asymmetry, and create a variety of shapes and sizes.

8. Choose the strongest composition, and use it as the sketch for Stage One of your painting.

Step 1: Draw the same quick sketch 5 times.

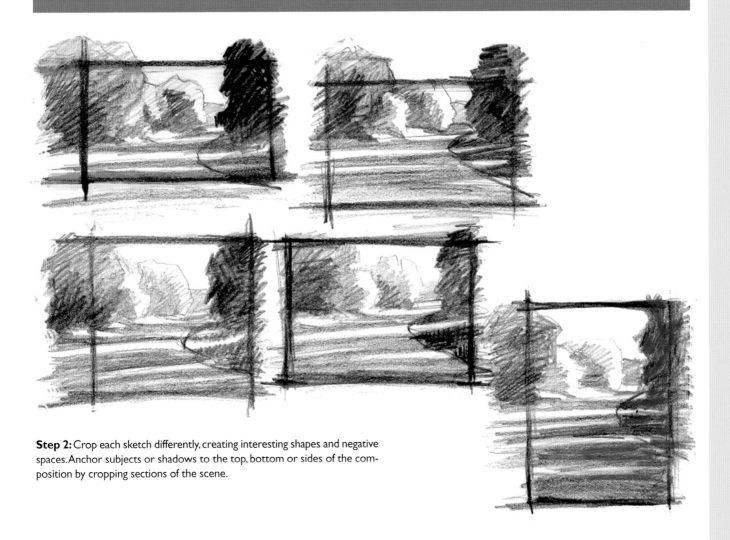

Step 2: Crop each sketch differently, creating interesting shapes and negative spaces. Anchor subjects or shadows to the top, bottom or sides of the composition by cropping sections of the scene.

Step 3: Choose the strongest sketch and use it as Stage One of your painting.

Step 4: Begin Stage One of your painting

Compositional Patterns and Rhythms

Every strong composition will reveal a basic design element or pattern that unifies the painting. These compositional patterns create mood, movement, and rhythm. The patterns take form in basic geometric shapes which strengthen and simplify the composition.

Each type of compositional pattern projects a different mood or feeling:

- Horizontal is restful
- Vertical is active
- Diagonal is dynamic
- S curve is flowing and graceful
- Circular is full and complete
- Triangular is stable

There is a natural, graceful rhythm seen in nature that is not always obvious but can be observed. Imagine a landscape where wind and water create the movement of trees and grasses. Or imagine the way hills and flat lands merge into one another.

A strong composition will demonstrate this natural rhythm in the flow of forms and shapes responding to each other. As a painter, learn to emphasize this rhythm and grace. Make it a bit more obvious, so it can be seen through your work.

We are translating a three-dimensional world into two dimensions. Shapes, colors, rhythm, pattern, and movement all need to be made more obvious, but not too exaggerated (or your painting will look like a cartoon).

VERTICAL

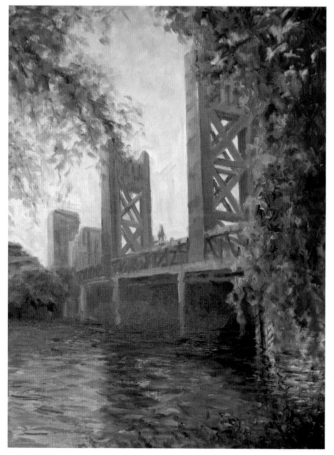

Tower Bridge, oil, 11 x 14 inches, Susan Sarback.

The strong lines of the vertical bridge, echoed by the choice of the vertical canvas, give this painting an active quality.

HORIZONTAL

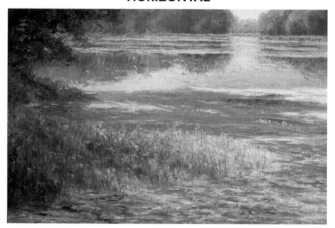

Afternoon Pond, oil, 20 x 24 inches, Susan Sarback.

This dominant horizontal subject and corresponding canvas orientation create a calm, restful feeling.

DIAGONAL

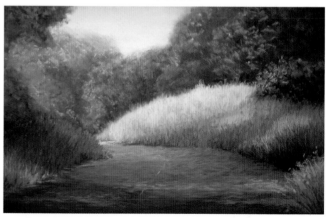

The Bike Trail, soft pastel, 17 x 10 inches, Irene Lester.

Notice how the diagonal lines of the trail on both the left and right sides create dynamic movement.

S CURVE

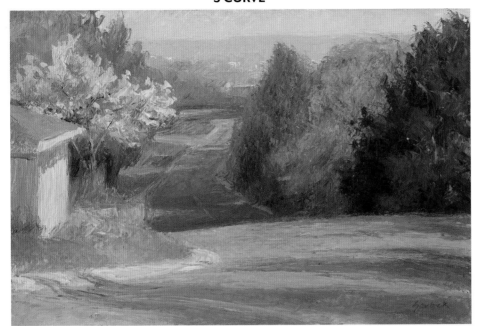

**Down the Hill,
Across the Street,**
oil, 11 x 16.5, Susan Sarback.

Notice the S curve created by the meandering roadway giving a rhythmic, flowing feeling to this painting.

TRIANGULAR

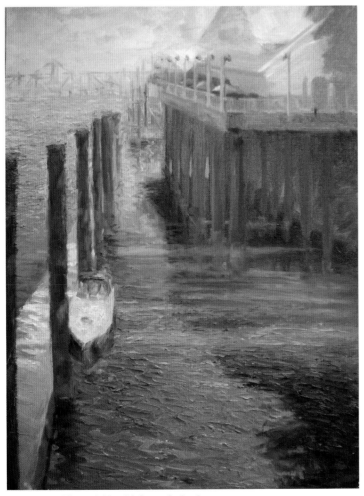

Down the Pier, oil, 12 x 16, Susan Sarback.

Notice how the triangular shape created by the poles and pilings (one point perspective) imparts a sense of stability to this painting.

CIRCULAR

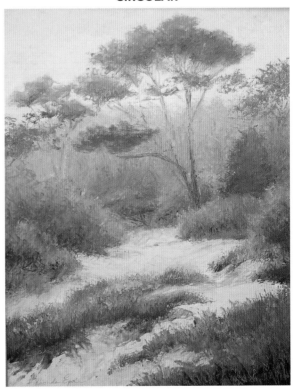

Colorful Carmel, oil, 8 x 12 inches, Rhonda Egan.

This composition is based on the circular rhythm of the ice plants in the sand curving up to the tree which arches back down to the plants. Circular compositions create a feeling of fullness and completion.

Full Color Seeing in Landscapes

Every landscape has its own particular character and feeling. For example, the sunny, summer, coastal marshland in this scene creates a bright, crisp impression compared with the humidity and chill of a foggy winter day. In this painting, the setting sun created a bright warm color in the distance. The challenge was to have the background recede yet still retain its vividness. I was also interested in creating movement through space in this flat marsh.

Landscapes have a sense of distance and atmosphere that still lifes usually don't have. Also, in landscapes, the local colors tend to be more earthy and natural. Look for the full spectrum of color within the range of local colors. Nature has both sweet and somber colors; the aim is not to be overcolored, but not to be too neutral, either.

Organic forms, such as trees, grasses, and clouds, are often more complex than man-made structures, such as houses or fences. Learn to simplify the mass of organic forms. You may need to edit elements—for example, a tree may need an awkward limb left out.

Location photograph: Marsh at Sunset
This is a photograph of a coastal marshland at sunset. The temperature is about 75 degrees, and it's a clear sunny day. The goal in this painting was to capture the quality of light and space with a simple composition.

Stage One:
Stating the major masses.
My initial color statements were painted simply with few masses and without describing details. Notice that everything in the direct sunlight was painted a warm color and the shadows were painted cool colors. On sunny days, begin with bold statements of pure bright color to capture the shock of bright sunlight.

This composition does not have 60% of its masses in shadow, but it works because of the large expanses of water. Water, even if it is in light, can compensate for a lack of shadow because in later stages of the painting, water will read as predominantly cool in color (reflecting the sky).

Compare the completed painting to the initial color masses. The final painting has the feeling of sunlight, but it's not as bold and shocking as stage one. Start boldly so that as you refine your colors, you won't lose the intensity of sunlight.

Stage Two: Refining the major masses.

Notice the cool blue added to the water. If I had started with blue, the water would not have the feeling of a warm, sunny day. Also, the large yellow mass in the right corner is now clearly differentiated from the yellow reeds in sunlight. By scanning the subject I was able to see how each of these masses differ from one another.

Stage Three: Developing three dimensions with color variations.

This shows the results of continued scanning, refining colors, and seeing and painting color variations. Sometimes I will have to push a color back and forth in different directions before I find the right color. For example, the water started out pink, became bluer, then I added some yellow, a bit more blue and a little green. There is no one right path to the correct color. Colors develop through repeated modifications. Notice the bands of color in each mass.

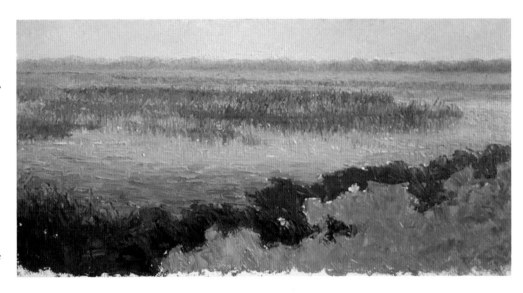

Stage Four: Painting more variations and developing edges

I began to add deeper, cooler colors to the large mass on the left. To see the color of the distant trees in sunlight, I compared them to trees in sunlight very near to me, which were not in the painting. This approach helped me to see the color as cooler than the near trees in sunlight, but still essentially warm, since it was directly in the light plane. In this stage edges were also modified throughout the painting.

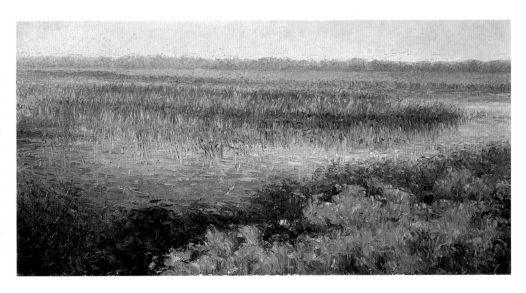

Down The Bicycle Path

What appealed to me in this scene was the long shadow and the way it changed as it fell across the grass (on the left), the pathway, and the dirt and dried foliage (on the right). The curve of the road, with the large dark tree in shadow and the distant trees in sunlight, created a dynamic subject. This was painted outdoors—in plein air—on a sunny autumn morning. It took about 1-1/2 hours to complete.

Stage One:
Stating the major masses.
This painting had three main shadow areas, and the rest was in sunlight. I began with bright pure colors—cool on the shadows and warm in the sunlight.

Stage Two:
Refining the major masses.
In this stage I painted the masses so that each was distinctly different from the others. Notice the dull warm color in the distance compared to the brighter colors in the foreground.

Stage Three:
Developing three dimensions
with color variations.

Notice the bands of color in the distant trees and in the large dark foreground tree. Each mass in the painting has two, three, or four variations, but the trees have the most obvious variations. The masses on the path and the cast shadows all show subtler variations. Look at the area of light within the cast shadow on the path. This is handled as a simple variation in Stage Three. In this stage I also painted in some of the tree trunks to clarify which trees were in the foreground and which in the background.

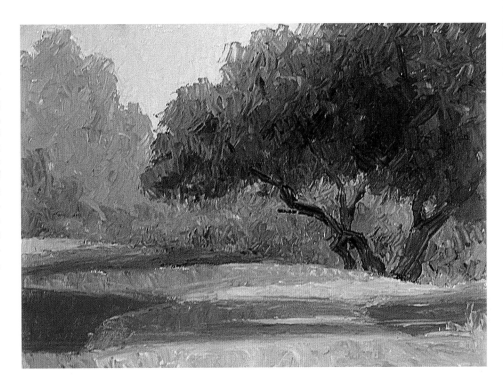

Stage Four:
Painting more variations
and developing edges

Notice how the cast shadow across the path now has more variations that reveal a dappling of light. The background trees now recede even more because the color variations have increased in number and subtlety and because the edges are diffused. In the distance, colors in the light are generally duller and cooler than in the sunlit foreground. In the foreground I painted more detail in the tree trunks and in the patterns of light in the tree leaves to make them come forward. The focal point in this painting is at the base of the tree trunks and the edge of the path. Notice how the edge is sharpest here with the highest contrast in color and value.

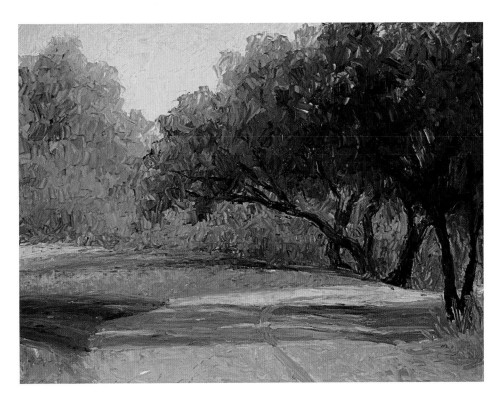

Seeing and Painting Patterns of Light — The Pond

Your eye is led by patterns of light. The way to visually organize a complex scene is to notice the patterns of sunlight and shadow. Think of a subject as being patterns rather than the actual objects. People generally respond more to the patterns of light and color than to the subject matter.

I chose this scene because of the rhythmic shapes and complex colors, and because it had a lot of visual activity. I liked the coolness of the scene, even though it was in full sunlight.

As I began sketching, the surface of the pond appeared very complex. To simplify it, I looked to see what was in shadow and what was in light. This way, I was able to focus my attention on painting the light rather than on describing the subject.

After I saw the main areas of shadow and light on the

Location Photograph

algae, I looked for the reflections. Some of them were in shadow and some in light. I saw them as patterns of color, not just value differences. The blue of the water in shadow was a cool color, but in the sun it was a much warmer color. In this painting, I had to observe what was warm and cool in the water, but still make all the colors read as part of the pond.

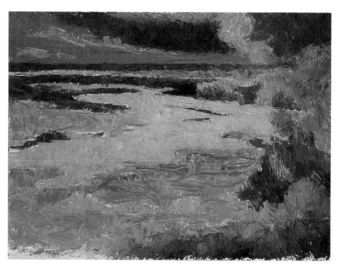

Stage One: Even though this is a complex subject, I simplified the scene into the major masses of light and shadow using value and temperature. Some colors are not obvious, such as the pink of the pond. This is the reflection of the sky in sunlight, which is warm. Although the majority of the color masses are in light, the coolness of the water will ultimately compensate for the lack of shadow.

Stage Two: This stage shows the further development of the major color masses. Even in a complex scene, I rely on color and shape relationships rather than descriptive drawing. Notice that the sky reflection in the pond became cooler (bluer) yet the underlying pink kept the water in sunlight. The painting now looks like a pond even though it is still somewhat two dimensional.

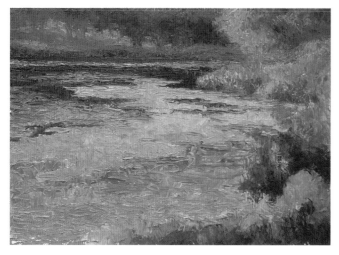

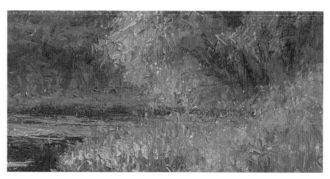

Detail: This section shows how details are created out of smaller and smaller color variations. The forms are not described with drawing but are built out of color. For example, the trees in the background are painted as areas of color, yet they appear to be trees.

Stage Three: This step shows the further development of the major color masses. At this stage, I painted more of the color variations within each mass and three dimensions began to emerge. For example, notice the bands of color on the algae. The main color is orange but the variations within that mass are distinct. The front band is green-orange, the middle band is yellow-orange and the back band is a blue-orange. These colors were layered and not fully blended.

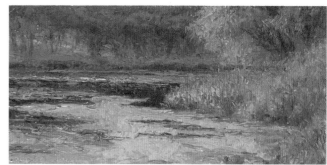

Detail: This is a close-up of the focal area—where the algae, the dark reflective water and the foliage meet. Notice that the sharper edges, higher contrast and temperature contrast (warm /cool) combine to create the most dramatic area of the painting.

Stage Four: In this stage I indicated the distant trees, placed more variations in the foliage, the water, the algae, and developed the edges (mostly of the algae—the focal area).

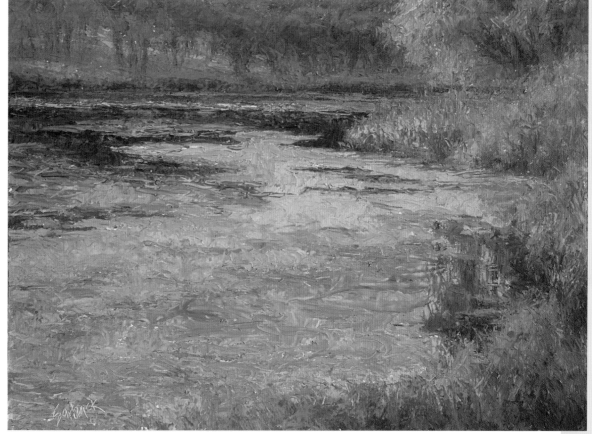

Sunlit Pond,
oil, 12 x 16 inches,
Susan Sarback.

Quick Plein-Air Paintings

All these paintings were completed in one session, often in an hour or two. They show how full-color seeing and painting are based on the relationship of the major color masses. These paintings were done on location. Plein air paintings of this kind are a great way to train yourself to see the scene in terms of light and color instead of subject matter.

Peju Winery, Napa Valley, oil, 9 x 12 inches, Susan Sarback.

Storm Approaching, oil, 9 x 12 inches, Susan Sarback.

Supplies for Plein-Air Landscape Painting

San Diego Haze, oil, 9 x 12 inches, Susan Sarback.

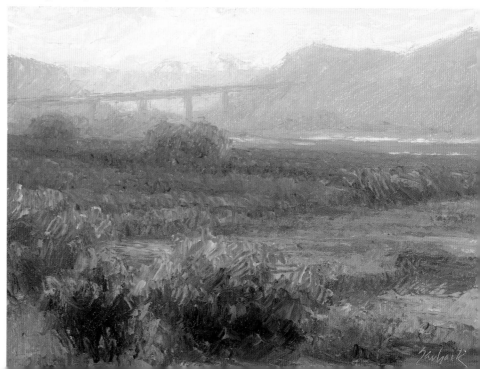

Portable, lightweight easel
Oil paints or soft pastels
Vine charcoal (for oil painters)
Visor or hat
Paper towels or soft cloths
Painting surface (canvas, boards, pastel paper)
Sunscreen lotion
Palette knife (for oil painters)
Hard surface to lean on (for pastel painters)
Optional:
Portable seat
Umbrella
Water
Note: For oil painters, wear a dark, dull shirt that doesn't reflect into your painting. White or bright colors will reflect and distort the appearance of your colors.

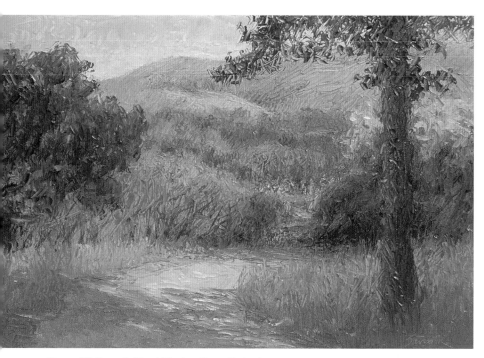

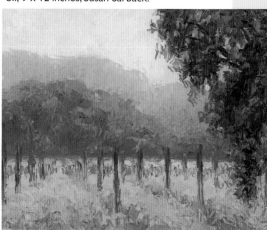

The Mustard Field,
oil, 9 x 12 inches, Susan Sarback.

Carmel Valley, oil, 12 x 16 inches, Susan Sarback.

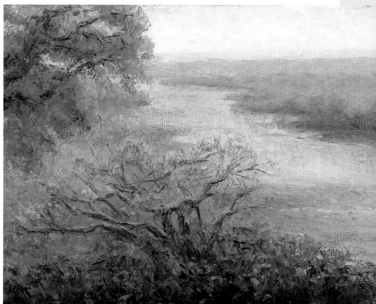

Overcast River, Morning, oil, 11 x 14 inches, Susan Sarback.

Spring Haze, oil, 11 x 14 inches, Susan Sarback.

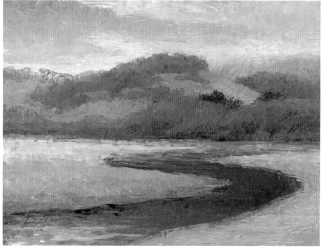

Coastal Clouds, Carmel, oil, 9 x 12 inches, Susan Sarback.

Painting Water

Painting water has its own unique challenges. Water, more than any other element, takes its color from its surroundings. A body of water, like an ocean, lake or pond, will be affected by the color of the sky as well as the surrounding land. As the season, the weather and the time of day, shift, so will the color of the water.

Water is a complex subject. Not only does it have shadows, it has reflections, often from several sources at once, and a constantly changing surface. Yet, the process of painting water is the same as for simpler subjects.

If the river, lake, ocean, etc. is in direct sunlight begin it as a warm color, just as you would if you were painting land in light. If the water is in shadow (or if you are painting on a cloudy day) begin it as a cool color.

In the second stage, other warm and cool colors are added. Most water is not overly bright and to subdue the tones you may need to add many colors. Since water reflects the sky, trees, buildings, etc., the colors that you add will be influenced by the surrounding colors. For example, when painting a river in sunlight you may need to start with pink or yellow. In the next stage you may add cool colors that reflect the sky or trees (these colors are often layered and not fully blended unless you want the water to appear dull).

Different times of day are painted in the same manner. Although early morning light is very different from late afternoon light, you still begin with warm colors for areas that are in sunlight and cool colors for areas that are in shade.

Water, however is much more sensitive to its surroundings than land. Perhaps the most challenging thing about painting water is that it does not stay still. It's highly responsive to the wind. So don't try and paint all the changes because you will constantly be chasing the wind. Discover an interesting pattern on the water and stick to it. Only change it if you prefer another pattern—but don't keep changing it.

Remember to squint and scan to see the overriding patterns of light, shade, and movement.

Learn to be fluid in your strokes (just like water)—don't paint water like it's trees or grasses. See and feel the rhythm and movement of the pattern that is specific to the body of water that you are painting. Each river, lake and stream is unique.

Always rely on your vision and not on rules or formulas. However there are situations in nature that are somewhat predictable. Here are a few things that you can look for when painting reflective water i.e., rivers, lakes, or ponds:

1. Often on a sunny day the land has more contrast than its reflection in the water.

2. Subjects in direct sunlight will generally reflect cooler, duller, and darker in the water than they appear on the land.

3. Subjects in shadow may reflect cooler, duller, and lighter in the water.

TIPS

Painting Reflections in Water

- Subjects in direct sunlight often reflect darker (light reflects darker).

- Subjects in shadow often reflect lighter (dark reflects lighter).

- Most subjects will reflect (appear) cooler and duller in the water.

- On a sunny day, the land appears to be higher contrast than its reflection.

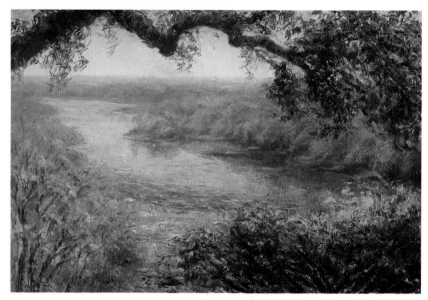

River Morning Vista, oil, 16 x 24 inches, Susan Sarback.

This was painted on a sunny morning with a soft hazy light in the distance. I began the sky with a light lemon yellow and the water with a light Permanent Rose. I then added the soft light yellow, light Cerulean Blue (mixed with white) and light Viridian Green to the water. I layered these colors so that the warm colors underneath were still apparent and the water still appeared to be in direct sunlight. In Stage Three I emphasized the bands of colors from front to back to show distance. Notice that distance is created in the painting by emphasizing the texture and contrast in the foreground and diminishing them farther back.

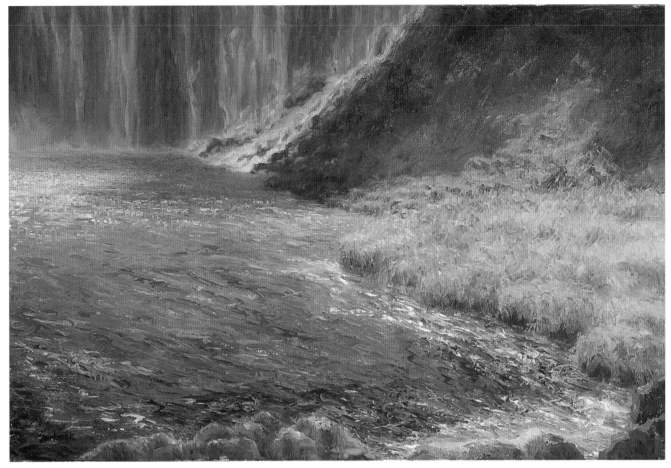

Shadow Falls, oils, 20 x 30 inches, Susan Sarback.

The front half of this painting is in light and the back half is in shadow. This light pattern cuts the strong diagonal in the composition. The water in the distance appears hazy because of the cool, dull colors and the softer brushwork, while the water in front rushes forward, with contrasting colors and active palette knife strokes.

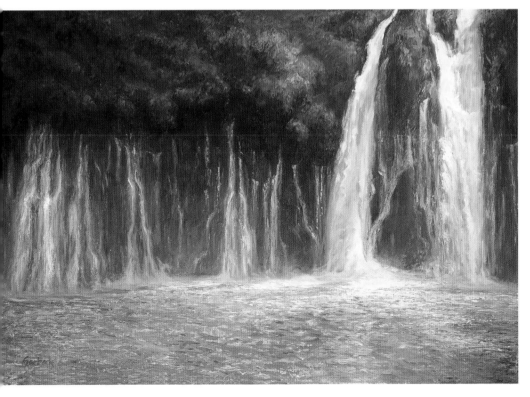

Falling Water, oils, 20 x 30 inches, Susan Sarback

This composition follows the "one third rule" because it is divided in thirds: the overhanging trees, falling water and pooled water. I painted the soft misty water with a brush, and the pooled, more turbulent water in the front third of the composition with a knife. In Stage One I painted the pooled water a rich pink. Later I added bright yellows, blues, violets and greens, creating an iridescent effect by layering instead of blending these colors. Had I blended them they would have appeared dark and dull. Notice how the subtle bands of color, both horizontal and vertical, create movement from left to right as well as from front to back in the pool.

Using Light to Unify a Complex Scene

Landscapes can appear very complex. Outdoors everything may look interesting yet deciding what to paint is not always that easy. If you focus on all the beautiful, interesting elements in the landscape the painting will often look busy because there is no unifying element. On a sunlit day the best and simplest way to look at a landscape is to see the patterns of light and shadow. These patterns can be the foundation for a good design and a strong composition—the unifying element in a landscape.

In this painting, I focused not on an interesting tree, or the many colors in the water, but on the large rhythmic patterns of light and shadow throughout the scene. These patterns created the basic structure of the painting. Once this was established, the suggestion of trees, hills, water, etc. fell into place.

Location Photograph

Initial sketch: Initial sketch. This was a complex subject: algae floating on the pond, the reflection of the sky and the trees seen in the water and the background trees. In this stage I simplified the scene by creating large masses of different sizes and shapes.

Stage One: Stating the major masses.
In Stage One I painted seven masses of color. Three are in shadow (cool colors) and four are in the light (warm colors). I ignored the details and just painted the patterns of light and shadow.

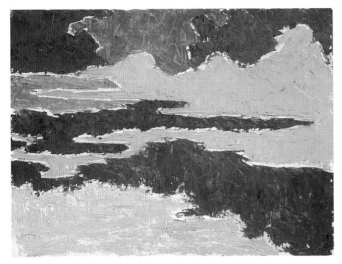 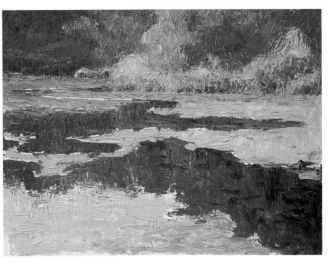

Stage Two: Refining the major masses.

In Stage Two I refined the major masses by adding color directly into the masses that I painted in Stage One. Notice how all the colors are less bright than in Stage One yet they retain the essence of the underlying color. The composition creates the foundation of form and space. The color relationships of the masses create the quality of light as seen in the final painting.

Stage Three:
Developing three dimensions with color variations.

The bands of color now begin to create the illusion of depth and space in this painting. Notice how the bushes and trees in the background begin to emerge, the sky reflection in the water has depth, and the algae is receding on the pond surface. Even though I could see these distinctions in Stage One, I restrained myself from painting them until this stage. If you can achieve a strong foundation in Stage Two the rest of the painting falls into place.

Stage Four:
Painting more variations and developing edges.

In the final painting it's obvious what the subject is. Notice that there are no details. Everything is suggested with more color bands or variations in each mass. In this stage I added a suggestion of tree branches, sky and tree reflections in the water, and more color variations in the algae. Edges were differentiated from one another. I kept the crisp edge at the focal point (in the upper left quadrant of the painting) where the water, the algae, and the trees meet. I modified the edges in the foreground by diffusing colors and painting broken edges, which softened the tree reflections in the water as well as the edges of the algae.

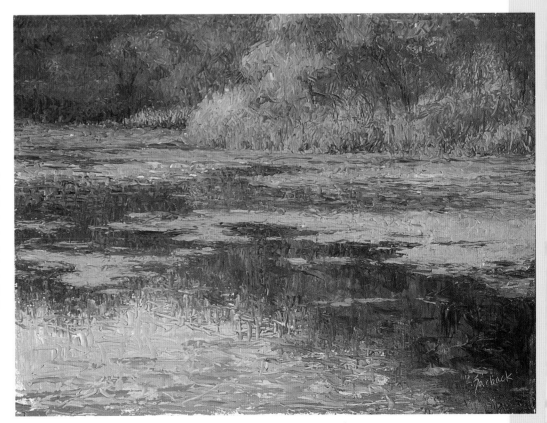

The Pond at Sunset, oil, 12 x 16 inches, Susan Sarback.

How Paint Strokes Create Form and Distance

Many artists use brushwork or paint strokes to show spontaneity and movement in their paintings to express the "life force," growth, and passion. Other artists prefer to use flat planes of color with no visible strokes. They rely on color relationships, composition, and subject matter to convey their message.

Using paint strokes and using flat planes are simply different ways of painting, and both are correct. But let's look at the way paint strokes enhance form and evoke the natural movement and growth patterns of the subject.

The Impressionists' brushwork echoes form, following planes and describing varied textures in rich paint. These painters were interested in capturing a sense of immediacy and spontaneity, shown by painting quickly and allowing texture and strokes to be seen without perfecting form.

In other words, theirs was not a tight rendering, it had few hard edges. They used decisive strokes of varying types: short quick strokes, long flowing strokes dragging color, wispy strokes, bold layering of color, and soft diffused layers of color. They suggested form through color and texture, as opposed to a clear description of things.

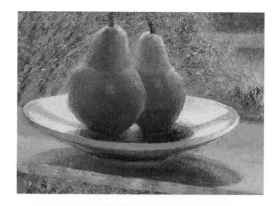

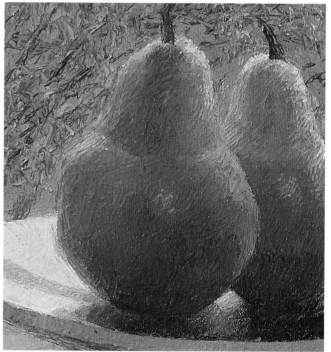

Two Pears on a Cloudy Day, oil 11 x 14 inches, Susan Sarback.

This picture was painted with a palette knife, using bands of color to create the form of the pear. The strokes are relatively small, softening and rounding the form and reflecting the quiet mood of a cloudy day.

Detail: Look closely to see that quite a bit of texture was created by using small strokes in differing directions.

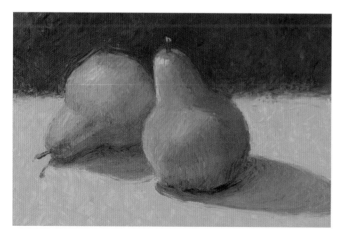

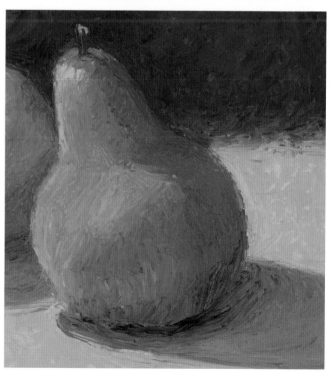

Pears, oil, 11 x 14 inches, Susan Sarback.

This picture was painted with a palette knife in about an hour and a half. The rapid, spontaneous strokes are loose and obvious and echo form as they follow the planes of the pears.

Detail: Notice how each plane change is a color change and a change of stroke direction.

If using brush strokes, palette knife strokes, or pastel strokes, you have a number of things to consider:

1. Vary the type of strokes throughout the painting; don't keep them the same everywhere.

2. Let the direction of stroke follow the planes of the subject and the growth pattern.

3. Don't let strokes go in one direction throughout the painting; vary the direction. Try short strokes, long strokes, wispy strokes, layering of color, thick paint, thin paint, and soft diffused color.

4. The amount of texture should also vary throughout the painting. Generally there will be more texture in the foreground and less in the background, usually more at the focal area and less away from the focal area. In fact, in the distance or further away from the focal point, there may be no texture, but rather a use of flat color.

HERE ARE SOME THINGS TO REMEMBER:

Masses can either be painted with flat color or show strokes and texture.

An artist can paint with large areas of paint that are flat (blended and smooth) and without texture as opposed to using two or more colors that are layered or woven together to create the illusion of a solid mass of color.

• **Paint strokes can enhance form.** The direction of strokes can help to suggest the planes of an object, which will enhance the illusion of a three-dimensional form.

Cobalt and Orange, detail, oil, Susan Sarback.

This painting was done rapidly with a palette knife. Note that volume is created by clear bands of color and decisive paint strokes. The strokes are not rounded, but follow the planes of the forms, even in the cast shadow.

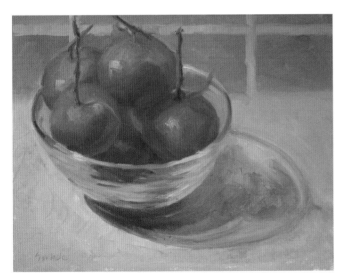

Tangerines in a Glass Bowl, oil, 11 x 14 inches, Susan Sarback.

This was painted with a brush. Strokes blend more and are softer than with a knife. Colors fade into one another with a brush because the bristles often create softer edges between colors. This was painted wet into wet in one session.

Compare the soft brush strokes to the more dynamic and textural palette knife strokes in other paintings.

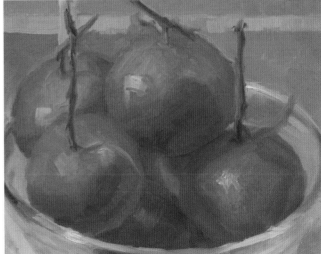

Detail: Look closely at the tangerines. Notice that the strokes are not all blended. The colors are still distinct and the bands are seen but the strokes are softer than they would be with a knife. There is less texture but volume is still felt.

Strokes with Soft Pastels: The same principals used with oils apply to soft pastels. Notice the close up details of pastels on this page. Some areas are blended, but most use varied stroke thickness, varied stroke direction and layered strokes.

• **Strokes are not the same everywhere.** If the strokes are applied in different ways, this helps create a greater illusion of form and space, and your painting will be more convincing.

• **Vary the direction of your strokes.** Use vertical, horizontal, or angled strokes. Don't have every stroke go in the same direction.

• **Pay attention to the amount of texture, paint, and strokes.** Sometimes your strokes will be thicker (using more paint), sometimes thinner (using less paint). Sometimes your textures may appear smoother and other times more varied. Use more texture near the focal point and less texture as you get farther from it. The artist helps the eye move toward the focal area, not wander all over the painting.

• **Texture can be more varied with a palette knife than with a brush.** With a palette knife, you can more easily layer and weave colors. Of course, when using a palette knife you can blend colors to different degrees, from smooth to textural.

• **Texture is softer with a brush.** Brush strokes tend to blend more easily than palette knife strokes. Edges are more easily softened, and colors can appear to fade into one another. But there are many types of brushwork. Painting wet into wet or painting wet on a dry surface will create different effects.

The amount of oil or medium added to the pigment will also

Detail, soft pastel, Marianne Post.

Details, soft pastel, Irene Lester.

affect the appearance of the strokes. Thinner paint (with more oil or medium) will appear more fluid while thicker paint (with less oil or medium) will appear richer and more substantial.

• Strokes help suggest the texture of subject matter. Water, grass, leaves, bushes and glass—each calls for a certain type of stroke; the direction of stroke will actually reveal the subject, the quality of light, and the growth patterns we observe. All subjects require different strokes.

To see and feel the best texture to use, think in terms of being in tune. Show the feeling or the life force in your work by coming into harmony with your subject: a wind-blown tree, rushing river, dynamic waterfall, or still morning pond.

Strokes follow growth patterns, wind patterns, and in fact, the whole texture of the day. Observe these well. You'll see how a lake, an open field, and a line of poplars all call for different strokes. We're always discovering how strokes go with the mood of the setting: Is it foggy, windy, cloudy, sunny, hot or cool? Your strokes should follow the planes, not the form of your subject. See the example of the pears on page 90 and notice that circular strokes aren't used for round objects. Every plane change is a color change and a change of stroke direction. Again, strokes follow the planes.

• Strokes can suggest distance. Create more texture for objects up close and less for those in the distance.

The Delta King, oil, 12 x 16 inches, Susan Sarback.

This was painted with both a brush and a knife. Compare the broken, bold strokes in the water, painted with a knife, to the flat, simple, blended strokes of the distant buildings, painted with a brush. The texture of the midground trees was created with both brush and knife, and the boat mostly with brush but some knife. This variety of paint strokes helps create form, atmosphere and distance.

Searching High, oil, 16 x 24 inches, Susan Sarback.

This was painted with both brush and knife. The dynamic, layered paint strokes in the upper sky were done with a knife, while the softer, more blended colors at the bottom of the painting were brushwork. The leaves of the trees were painted with a knife using broken edges and thicker paint to bring them into the foreground and create a textural difference between the trees and the sky. The branches were added at the end using both a brush and knife.

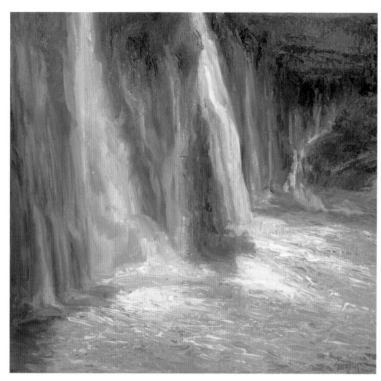

Burney Falls, detail, oil, Susan Sarback.

This was painted with both brush and knife. The falling water is wispy and feathery which lends itself to brushwork. In contrast, the pooling water at the bottom of the falls is actively churning. Here I layered the colors with a palette knife, using thicker paint.

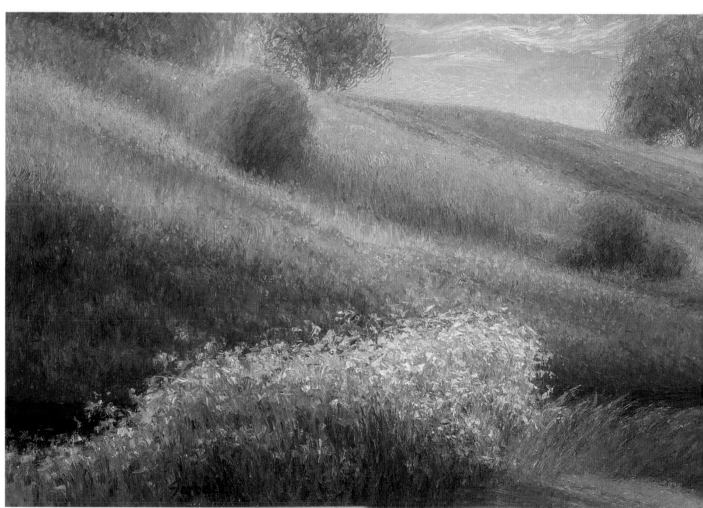

Fair Oaks Meadow, Spring, oil, 20 x 30 inches, Susan Sarback.

This was painted with a knife. Notice the heavy broken strokes of the flowers in the foreground and the progressively smaller strokes as the hillside recedes. The direction of the strokes follows the growth pattern of the foliage.

Full color exists in the deepest light keys as well as in the brightest. Colors may be deep and somber yet full and rich. Full-color seeing and painting is not about creating pretty, pastel colors. If your paintings consistently look too "sweet," do a few studies in full shadow. On the other hand, if your paintings look muddy, do some outdoor studies of brightly colored objects on a sunny day. The range of color in nature is greater than you may think.

I chose this scene because it had strong interesting shapes and unusual color. The water was dark, dull, and a bit reflective. The trees were bright and a shocking contrast to the background cliff in full shadow. All of the colors, whether bright or dull, were rich and painted with the full spectrum. Notice the trees in light are painted as patterns and shapes of light rather than "trees."

American River Shoreline

Initial sketch: In framing this composition I chose to eliminate the sky so that the focus would be on the trees, water and curve of the shoreline. Then I simplified the scene into 6 masses. In this painting there are straight lines, a diagonal, a large curve, large and small shapes, and unusual organic shapes (the trees). All these elements add interest and movement to the composition.

Stage One: The only large shadow mass in this composition is the background cliff, which I painted a deep Ultramarine Blue. Even though a good composition has more shadow than light, I knew that the dark reflective water would compensate for the lack of shadow. Every other shape was in light and therefore painted a warm color.

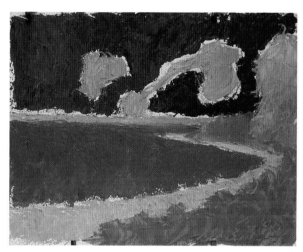

Stage Two: I kept the same number of masses and added colors to each mass to make the color relationships more accurate. For example, I added several warm and cool colors to the orange mass of the water to make it darker and duller. The more colors that are added to a mass, the duller it becomes. I kept the yellow of the sunlit trees bright.

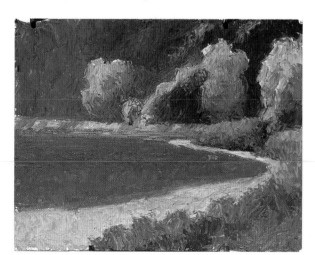

Stage Three: Bands of color were added to each mass to create space and form. Notice how the cool and warm bands in the water create recessional planes and the bands in the trees create three dimensional form. The bands in the foreground grasses were painted with looser strokes to follow the growth pattern of foliage. Compare these strokes to those used to paint the water.

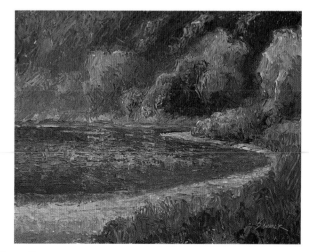

Stage Four:
American River Shoreline, oil, 11 x 14 inches, Susan Sarback.
In this stage I painted more variations in each mass. Notice how the cliff recedes more, the trees look fuller and softer, and the water now has tree reflections as well as surface texture (reflective sky color from the wind on the water). All the edges were modified.

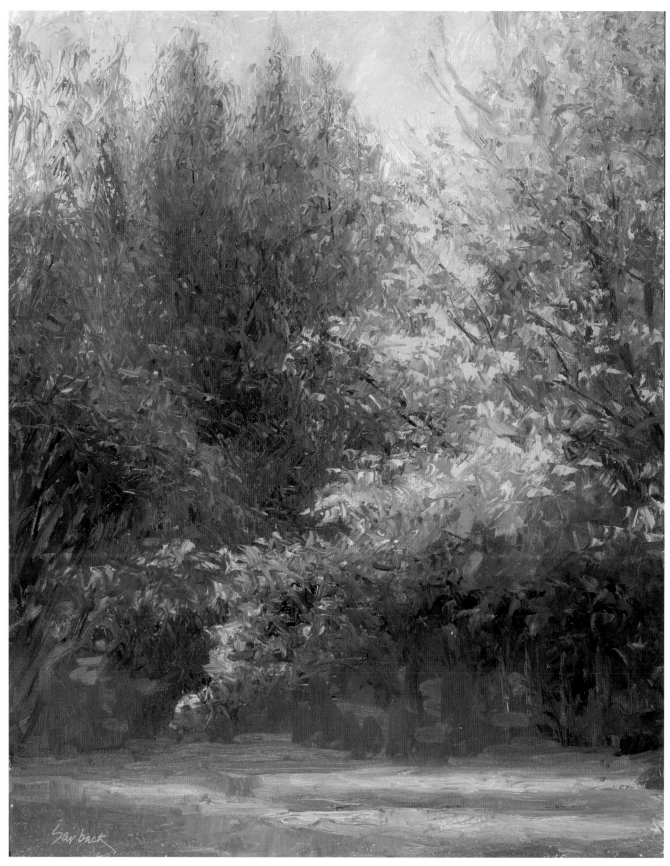

Falling Leaves, oil, 16 x 20 inches, Susan Sarback.

Chapter Six

Painting the Light Key: The Many Qualities of Light

The further I go, the more I see how hard I must work to render what
I am trying for, that instantaneousness. Above all the outer surface,
the same light spread everywhere....For me, the subject is insignificant.
What I wish to reproduce is what is between the subject and myself.

CLAUDE MONET

The "instantaneity" that he wanted was first of all a principle
of harmonious unity: the permeation of the entire scene
with an identical quality of light and color.
He was trying to stop time, not hurry it along.

WILLIAM SEITZ (ABOUT MONET)

If I could make musicians out of all of you,
you would benefit as painters.

JEAN-AUGUST-DOMINIQUE INGRES

If you have done your job well, anyone can tell if it is morning
or afternoon light by the color you use.

CHARLES HAWTHORNE

The Duc de Trevise, a French collector of paintings reported this conversation he had with Monet: "Master, critics in the future…will be at an even greater loss to explain your famous 'series' to make people understand that you composed entire collections of canvases on a single motif. Philosophers will claim that it is philosophy…

"Monet replied, "Whereas it is honesty. When I started, I was just like the others; I thought two canvases were enough—one for a 'gray' day, one for a 'sunny' day. At that time, I was painting haystacks that had caught my eye; they formed a magnificent group, right near here. One day I noticed that the light had changed. I said to my daughter-in-law, 'Would you go back to the house, please, and bring me another canvas.' She brought it to me, but very soon the light had again changed. 'One more!' and 'One more still!' And I worked on each one only until I had achieved the effect I wanted; that's all. That's not very hard to understand."

What Is the Light Key?

Monet demonstrated with masterful clarity how the overall lighting effect of a scene will move through many changes, based upon the time of day, the season, the weather, even the geography. Monet called the overall light condition "the envelope of light in which all things are contained." Charles Hawthorne, borrowing a term from music, used the phrase "light key" to describe the same thing. The light key is the overall light condition, affecting everything in view.

In music, the key of a piece provides an underlying unity—generally, any note out of key will sound discordant. In fact, certain keys have distinctive sound qualities by which they can be recognized. Major keys, for example, are lighter and happier, whereas minor keys lend themselves to contemplation and reflection.

Similarly, in painting, the light key unifies the painting. Everything seen under one quality of light stands together as a harmonious whole. A collection of differently colored objects, such as two apples and a white vase on a blue table, viewed under the same light would still have a certain unity by virtue of the common illumination.

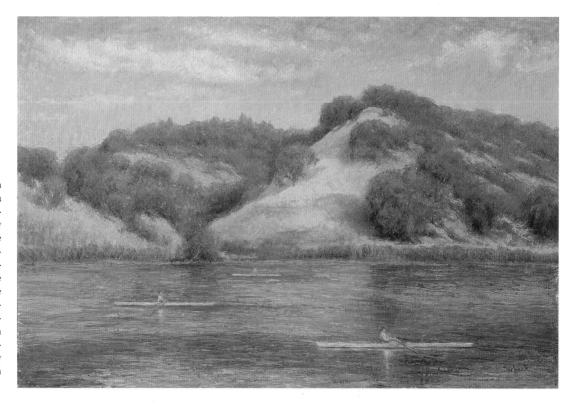

Lake Natoma,
oil, 24 x 36 inches,
Susan Sarback.

This was painted in Northern California on a summer morning. On a sunny day like this, where there is very little humidity, the colors are highly intense. Notice the depth created by the full spectrum of color seen on the hillside and reflected in the river. Recessional space is created by the bands of color on the distant trees.

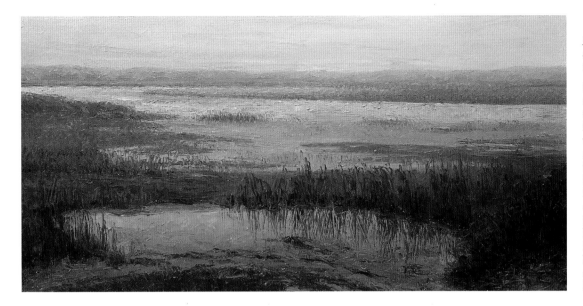

Marsh at Sunset, oil, 12 x 24 inches, Susan Sarback.

Sunset is often a visually dramatic time of day. Notice the intense contrast of warm colors in the distant sunlight, and the cool colors in the foreground shadow. Space and depth are created in this painting by the strong bands of color moving from front to back as well as by the subtle bands from left to right.

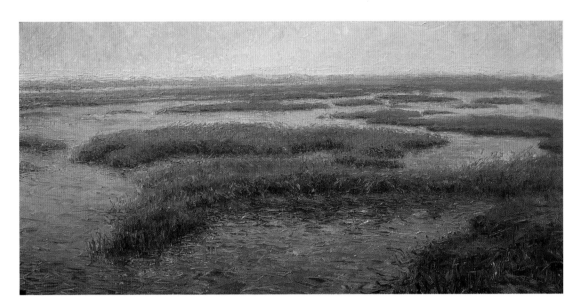

Cloudy Day Marsh, oil, 12 x 24 inches, Susan Sarback.

On a cloudy day the colors are generally cooler and less contrasting than on a sunny day. In this painting there are both dark and light saturated colors as well as muted colors. In Stage One all the colors began cool, since nothing was in sunlight. In the second stage the warm colors were added as needed to adjust the color relationships.

How to Identify Light Keys

Just as musical keys are identifiable, light keys are too. The most obvious distinction is between a sunny day and a cloudy day, but an almost infinite variety of light keys exists. The soft, hazy light of summer twilight by the ocean is easily distinguished from the sharp clarity of a clear winter morning on a mountaintop. Even the same kind of day, such as a sunny spring afternoon, will have a different quality of light in the tropics than, for example, in the Arctic. Many influences combine to create the light key—the overall atmospheric lighting condition that affects all that a painter sees.

- **Sunny days:** highest contrast and purest colors
- **Cloudy days:** colors are often cooler, may be saturated or muted, (depends on the type of clouds)
- **Fog:** lots of white, can be pure or somber colors
- **Haze:** less contrast, cooler and softer edges than on a sunny day
- **Dry climate:** crisper edges, higher contrast, and brightest colors
- **Humidity:** softer edges and cooler colors than a dry climate

You can think of the light key as the color and quality of the pervading light. We may have a rosy light key at sunset and a blue-violet light key on a cloudy afternoon.

To capture the effect of the light, don't cast every color in the painting with the color of the light key, as if seen through a colored lens. The light key affects the color relationships in specific ways, discernable only through observation. Through full-color seeing, we can learn to be sensitive to the overall light key as well as to its effects on all the color relationships in a painting.

The Difference a Day Makes

California Overlook Series

These paintings were all created at the same location, but at different times of day and under different weather conditions. These nine images were painted on small panels, 9 x 12 inches, so they could be completed in one session. Some took 30 minutes and some up to 1.5 hours. I had to paint very quickly to capture the quality of light, especially near sunrise and sunset when the light and color always change rapidly. The light tends to be more consistent toward the middle of the day.

On a sunny day the best times to paint are early in the morning or late afternoon. The shadows are longer and the color more interesting. At midday the shadows are minimal which makes the subject appear "flat."

The first six paintings were completed on a sunny, midsummer day from pre-sunrise to dusk. The next three were painted on a foggy, a cloudy, and a stormy day. Each of these paintings is painted in a different light key. Notice how the colors in every mass in every painting are different from the other paintings. For example, look at the color of the sky in each of the nine paintings. See how the weather and time of day create different colors for each atmospheric condition.

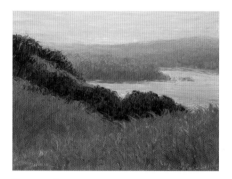
Pre-sunrise

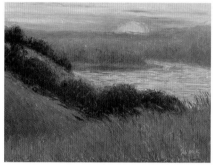
Sunrise

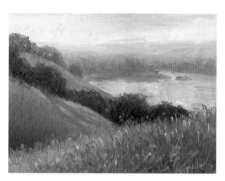
Early morning

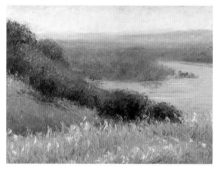
Mid day

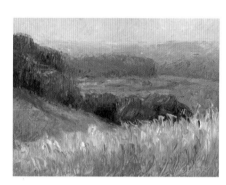
Sunset

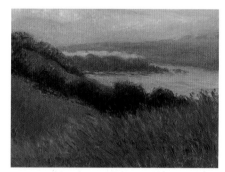
Dusk

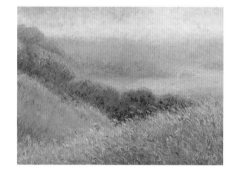
Foggy

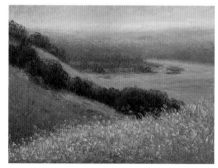
Cloudy

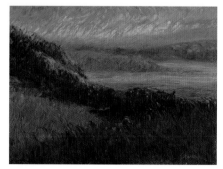
Stormy

Pre Sunrise, oil,
9 x 12 inches, Susan Sarback.

I painted this in 30 minutes, right before sunrise on a sunny summer morning. The sun had just begun to show a warm light in the sky yet the rest of the subject was still in shadow (and was painted with a cool color in Stage One). Although the colors were not very bright and somewhat muted, the full spectrum was used.

Sunrise, oil,
9 x 12 inches, Susan Sarback.

The colors at sunrise on this particular day were extremely bright, almost garish. The paint colors could approach but not fully capture the intensity of this subject.

Early Morning, oil,
9 x 12 inches, Susan Sarback.

After the sun rose a bit, I painted this scene in a little over an hour. You can still see the sun reflecting in the water. Only a few of the colors are still as bright as they were at sunrise. Most are woven or blended spectral colors which are duller but still quite luminous in relation to all the surrounding colors.

Mid Day, oil,
9 x 12 inches, Susan Sarback.

This was painted between 11:00 am and 1:00 pm when the shadows are minimal. This is not the best time of day to paint, and I don't recommend it, but I wanted to show the differences between the early, middle, and later times of the day.

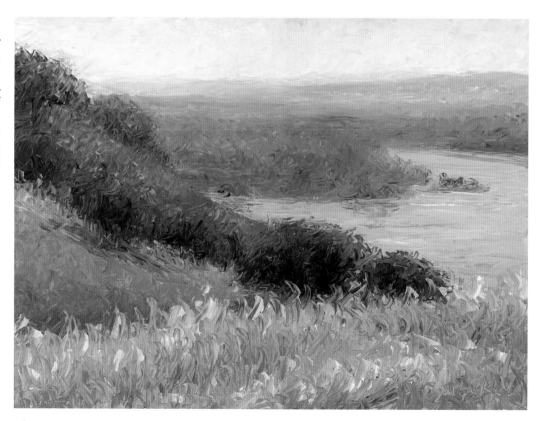

Sunset, oil,
9 x 12 inches, Susan Sarback.

The sun was setting behind me which created full sunlight on every mass in this scene. The colors started hot and rich. Notice the bright pink painted underneath the blue water, the bright red under the green trees, and the bright yellow in the foreground grasses. The heat of the day (about 102 degrees with no humidity) created these bright warm colors. This type of light occurs for only about 20-30 minutes, just before dusk.

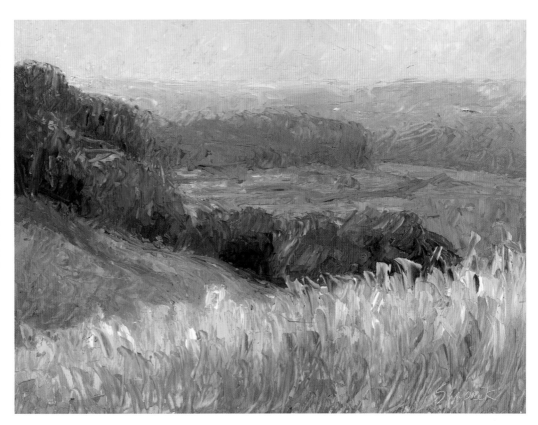

Dusk, oil,
9 x 12 inches, Susan Sarback.

The light changes quite rapidly right after sunset, just as it does right before sunrise. Most of the foreground is now in shadow. The distance has the last light of the day, rendered in the bright yellow-orange and the deeper orange glow blending into the far-away magenta hills.

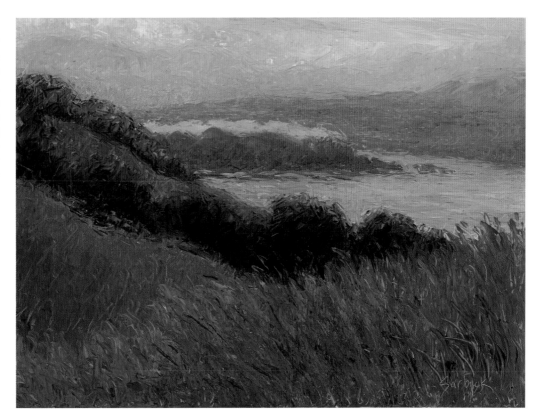

Foggy Day, oil,
9 x 12 inches, Susan Sarback.

The full spectrum of color is still seen on a foggy day but the light key is much different than on a sunny day. The colors are much lighter in value and there is less contrast. In Stage One all the masses begin as cool colors since there is no direct sunlight on any area. However, the cool colors are painted lighter (with more white). The values (light/dark) are usually limited to the middle and light ranges. In Stage Two, warm colors may be added where needed to dull the colors.

Cloudy Day, oil,
9 x 12 inches, Susan Sarback.

On a cloudy day all the masses begin as different cool colors. This is similar to the foggy day except the value range is much greater from dark to light. Notice the warm colors in the foreground. These colors, which were added to a cool base, look very different from warm colors painted on a sunny day (compare to the painting at Sunset).

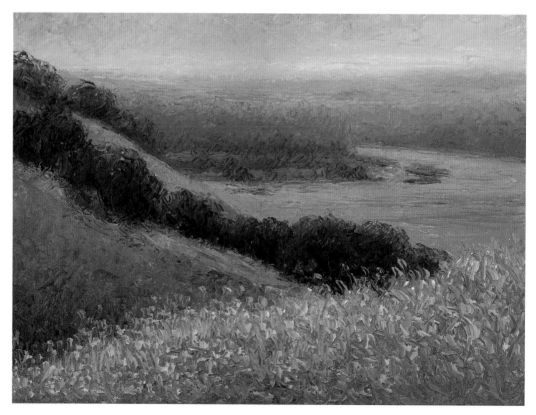

Stormy Day, oil,
9 x 12 inches, Susan Sarback.

As I was painting this, it was actually raining in the distance and I had to paint very quickly because the rain was approaching. In this painting you can still see the full color spectrum but notice how cool, dark and dull these colors are.

About the Light Key

Every weather condition contains the full spectrum of color but not in equal proportions or brightness. Learn to see and paint this beauty in all weather conditions.

Sunny days: Highest contrast and purest colors.

Cloudy days: Colors are often cooler, may be saturated or muted (depending on the type of clouds).

Fog: Lots of white, can be pure or somber colors.

Haze: Less contrast and softer edges than a sunny day.

Humidity: Softer edges and cooler colors than a dry climate.

Dry climate: Crisper edges, higher contrast, and brighter colors.

California Overlook, oil, 24 x 36 inches, Susan Sarback.

This is the same scene as the nine previous paintings but on a much larger canvas. It was painted in four consecutive morning sessions of about 1.5 hours each, on a sunny day with a bit of haze. Since I had more time to develop this painting, I was able to create very clear differences between the foreground, middle ground, and distance. Notice that the foreground has more texture, higher contrast and brighter colors. There is less distinction in the middle ground and even less in the distance. Perceiving these differences will enable you to understand how to create atmosphere and space.

TIPS

Creating Atmosphere and Distance

Here are some general guidelines for creating atmospheric perspective. These often hold true but are not formulas to follow.

Foreground: Highest contrast, brighter colors, more details, more texture.

Background: Cooler colors, fewer details, less texture, less contrast, dark colors get lighter, bright colors get duller as they recede.

Size: Trees, buildings, people, animals, etc., all decrease in size as they recede.

An Overall Atmosphere

For several years while studying, I heard about the light key, but I understood little about it and never saw it. Then one summer, while painting a sunrise over hills at the river, I realized that to paint the color of the distant hill correctly, I had to drench it in the yellow-gold light I saw in the sky. I saw that the whole scene was affected by an overall atmospheric condition. I had to exaggerate the effect of the yellow-gold light on the hill to get the color right in relation to the surrounding colors. I had discovered the effect of the light key.

Painting in this light key did not mean I had to add yellow-gold to all the colors. Instead, I saw how the blue shadow in the foreground had to be pushed lighter and cooler than I had initially seen it, so that it would appear in the correct light key. Not only did I relate the foreground to the distant hill (parts to parts), but I also had to relate both the foreground and the hill to the overall lighting condition (parts to whole). I saw this dawn light even more truly by painting the same scene at a different time of day, later in the morning, and by experiencing the contrast between the two light keys.

For the first time, after many years of painting the color relationships, I could see how the light key affected them. And by displaying correctly both the color relationships and the light key, that sunrise painting radiated a subtle unity that moved it noticeably beyond my former paintings.

Seeing the Whole

Understanding the light key means seeing the whole. It is the overall lighting condition that we see, and it permeates all the colors, unifying them in a subtle yet perceivable way.

If a color pops out of a painting, often it's because that color is not in the light key, just the way a discordant note in music sounds out of place. The light key transcends the details of a painting and grants it a harmony and radiance that can only arise out of the whole painting. The all-pervasive quality of light at a given place and time lends unity to any scene.

We learn to perceive the light key by comparison. For example, where I live in California, the weather is bright and clear much of the year. Painting over a long string of sunny days, I tend to forget, or overlook, the full warmth, intensity and high contrast of direct sunlight. The dramatic difference of a rainy or cloudy day helps me remember how fresh and bright a sunny day really is. To see the character of a particular light key, the painter must consciously experience other light keys as a frame of reference.

This kind of perception is analogous to the knowledge a portrait painter gains with experience. The artist who has painted hundreds of portraits will have greater insight into the specific character of a particular head than the student beginning her first portrait. The portrait artist compares each subject to all of the others he has painted. He may notice that a subject has unusually deep-set eyes, particularly full lips, and smaller-than-average ears. Prior experience creates a context that enables him to see the exact nature of each individual more clearly.

Similarly, by painting in different kinds of light, we can understand a variety of light keys. By comparing light keys and remembering the differences, we create a context from which to perceive the special nature of each one.

As we study the effects of light, we need to know how a scene looks under different light keys. We may rely on memory or on other studies and paintings to compare one time of day to another. When painting a noon scene, for example, we may compare it to our memory of that scene at dawn, and in the evening. Later, as we become more sensitive, we may also compare it to our memories of the late morning, mid-afternoon and late afternoon.

Henry Hensche once said, "If you only paint in one light key, you will get into a mannerism. Experience as many light keys as possible." We cannot truly know one light key until we know many others, for it is the comparisons among them that show us the uniqueness of each one.

Coastal Fog, oil, 7 x 14 inches, Susan Sarback.

I was standing near the edge of a cliff on the foggy Northern California coast one summer afternoon. The light was beautiful, it was very windy, and I was freezing. You can see by the rapidity of the paint knife strokes just how fast I was painting. Capturing a moment in time with a simple composition and unusual lighting can result in a unique painting.

Learning to Paint the Light Key

The best way to begin perceiving the light key is to study how it changes throughout the day—from morning to afternoon and early evening—and how it alters with the weather and seasons. Begin with the most basic distinction: comparing a sunny day to a cloudy one. Observe the difference in the quality of light when days are alternately cloudy and sunny, or when a cloudy day falls next to a few sunny ones. Paint the same scene on both a sunny day and a cloudy day. After becoming familiar with the differences between sunny and cloudy day light keys, tackle the differences that occur between periods of time, such as morning and afternoon. The overall quality of the light affects every color relationship, uniting all that is observed into a distinctive whole.

Just as in our initial study of color relationships, the study of light keys proceeds from the obvious to the subtle. Our beginning ability to distinguish sunny days from cloudy days expands to include more specific effects:

• hazy sunny mornings
• clear sunny afternoons
• foggy days,
• rainy days and so on.

As we gain experience, the subtleties of these distinctions become more and more apparent.

Doing small studies of the same scene at different times of day is a good way to experiment with light keys. Small studies (8" x 10" or 9" x 12") don't permit an emphasis on details. They provide good practice for capturing the light effect with a few main colors. Bold statements are useful for beginning painters; exaggerating the differences between morning and noon or afternoon and early evening helps make the difference easier to see.

Hot Hazy Morning, oil, 12 x 16 inches, Susan Sarback.

It was early on a hot, hazy morning. The sun had just risen and a beautiful golden light spread throughout this panoramic vista. I had to paint very quickly. I only had about one hour to capture the full spectrum of this fleeting warm light.

Morning Stroll on Van Dam State Beach, oil, 16 x 12 inches, Rhonda Egan.

This coastal painting was done on an overcast morning. Even though the colors began cool, there are plenty of warm colors added in the second stage. The painting shows the full spectrum, yet the atmosphere feels cool and cloudy.

Light Keys Change

The light key does not remain constant; it changes over time. After a certain period, it changes so much that work cannot continue on the same painting. There are several time periods to account for—the changes throughout a given day, the changes from day to day, and the changes from season to season. These will vary for different regions of the world.

In California, a sunny day contains about seven major light keys: sunrise, morning, late morning, midday, afternoon, late afternoon and sunset. These periods will be more subtle on a cloudy day. The amount of time the light stays relatively constant is shorter toward the beginning and the end of the day and longer in the middle.

For example, painters have only about thirty minutes to paint near sunrise and sunset, whereas midday is spread out over about one and one-half hours. A painting is often developed by working at the same time of day on a number of days with similar conditions.

Throughout the year, the light key changes with the seasons. The seasonal light keys depend on where you live. For example, the shift from summer to fall is quite dramatic in Vermont and much more subtle in Hawaii. Some painters work on paintings from one year to the next, as similar seasonal conditions recur.

Through the Trees, soft pastels, 11 x 14 inches, Marianne Post.

This pastel painting was created on a bright sunny day and began with high contrast bright colors. This establishes the clear patterns of light and shadow. Notice the bright yellows on the sunlit grass compared to the cool blues of the distant grass in shadow.

Early Spring, soft pastel, 9 x 12 inches, Irene Lester.

Backlighting often creates a dramatic painting. The sun was right behind the trees casting these long dynamic shadows. This high contrast type of lighting only appears on a sunny day.

Light Key Study — Folsom Bridge

This is a study of the same subject at three different times during a sunny day. Notice how all the masses (sky, river, distant hillside, bridge and reflections in the water) change from painting to painting. Painting a series like this is a wonderful way to understand light keys—the constantly changing rhythms of light and color in the atmosphere that surrounds us. These patterns of light and variations of color add a depth and richness to your paintings like nothing else can.

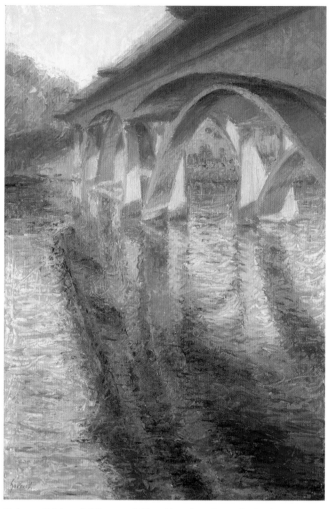

Folsom Bridge, 6:30 am, oil, 12 x 16 inches, Susan Sarback.

This was painted on a Spring day at 6:30 am. The river was somewhat calm, which made the reflections quite obvious. The cement bridge appeared golden in the sun, creating interesting patterns of light. Notice the warmth of the early sunlight permeating the hillside and river.

TIPS

Practical Tips for Landscape Painting

- Stand in the shade and keep your painting surface in the shade.

- Paint as long as the light is consistent enough: 20 minutes at sunrise and up to 2 hours in mid afternoon.

- Morning and late in the day are the best times to paint (more shadows).

- Paint quickly.

- If you are on location for a short time, paint on a small canvas; 8 x 10 or 9 x 12 inches.

…it is no small thing in painting to make people see what kind of day it is. I have seen things so sensitive that you could tell whether it was morning or afternoon.…I once painted a canvas and someone said, 'That looks like Sunday morning!'

I don't know why, but it did, and it was painted Sunday morning.

– CHARLES HAWTHORNE, *HAWTHORNE ON PAINTING*

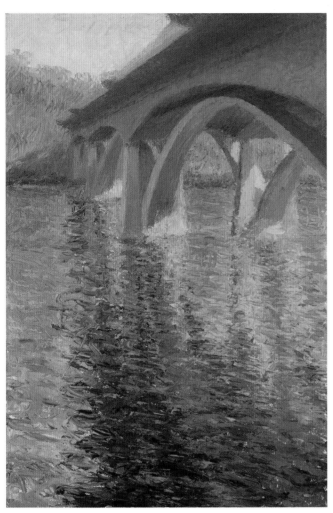

Folsom Bridge, 8:30 am, oil, 12 x 16 inches, Susan Sarback.

Just two hours later, this scene is considerably different in color. Now the water has a richer pink base with blues and violets woven into the windy surface, the sky has a light pink base with a richer blue layered on top, the distant hills are warmer and deeper. Notice how the patterns of light on the bridge have changed.

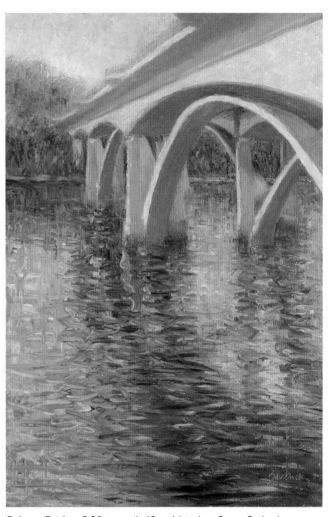

Folsom Bridge, 5:30 pm, oil, 12 x 16 inches, Susan Sarback.

Late afternoon light created this vibrant image. The "gray" bridge became golden, and the windy water reflected more greens and yellows from the sunlit bridge. Notice the blue violet of the distant hills, now in shadow. In this series of three paintings you can easily see how the colors and patterns of sunlight change throughout the day.

TIPS

Seeing and Painting Light Keys

1. Change canvases when the light key changes.

2. Paint the same scene under varying conditions to learn light keys.

3. When painting a scene, compare it to other light keys.

4. Study and compare a wide variety of light keys.

Light Key Study — The Bluffs

Not far from where I live in Northern California there is a beautiful State Park that the American River flows through. The bluff creates a wall of orange light on a sunny morning that is quite spectacular. Yet this bluff appears totally different throughout the year. This is a study of the same location painted in different weather conditions throughout the seasons. There's a hot summer sunny day, a hazy spring morning, a sunny spring morning, two different foggy winter days and a late autumn afternoon. Even though the compositions are a bit different, the location is the same. Painting in one location throughout the year is another superb way of seeing, painting, and understanding the light key.

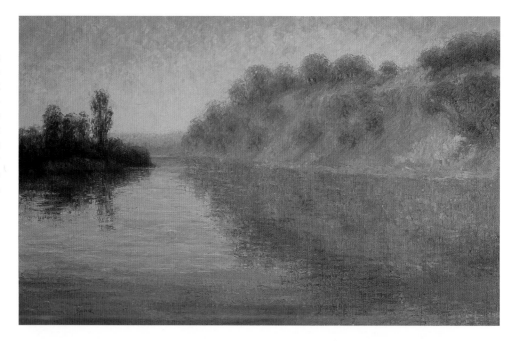

The Bluffs, Summer Sun,
oil, 20 x 30 inches, Susan Sarback.

It was 105 degrees on a bright summer morning. The bluffs were ablaze with hot light, in direct contrast to the deep dark shadows of the nearby island. There are areas of the world where you will find subjects as intense as this, but most regions will never see this quality of light. This type of light key requires dry heat with no humidity.

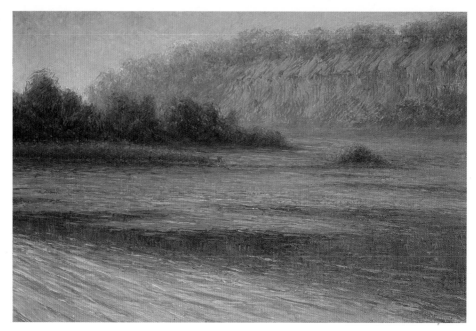

The Bluffs, Spring Haze,
oil, 20 x30 inches, Susan Sarback.

This was painted on a hazy spring morning. The colors are much less intense than in the previous painting, but the full spectrum is still present. The haze created a cooler atmosphere yet the warm colors are still visible. Notice how much cooler the distant trees are than the trees on the island. This helps create space, distance, and a sense of moisture in the air.

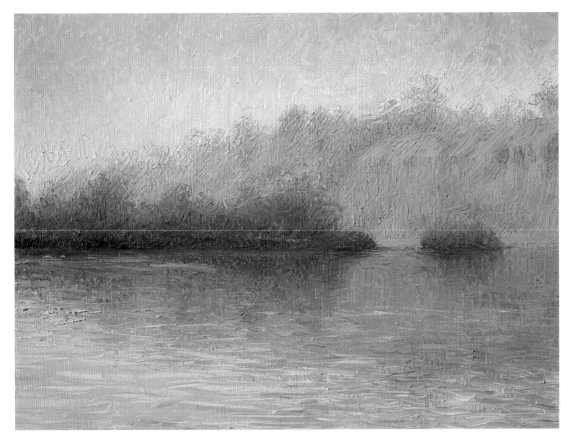

The Bluffs, Winter Fog,
oil, 11 x 14 inches, Susan Sarback.

This was painted on a foggy morning. The fog was not heavy, but it did create a soft, cool atmosphere. All the colors began cool and then the warm colors were added in Stage Two to create this somber yet luminous light key.

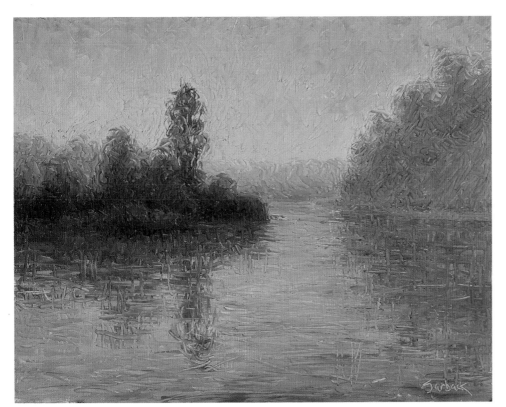

The Bluffs, Cold Winter Fog, oil, 9 x 12 inches, Susan Sarback.

Because it was cold, I painted this very rapidly. The fog was lifting and I wanted to capture this light key. Not all fog is the same. You can see the difference between this and the previous painting. This painting has a warmer and duller light key than the other, which is much cooler. There are no formulas for the light key. Simply observe all the subtle nuances.

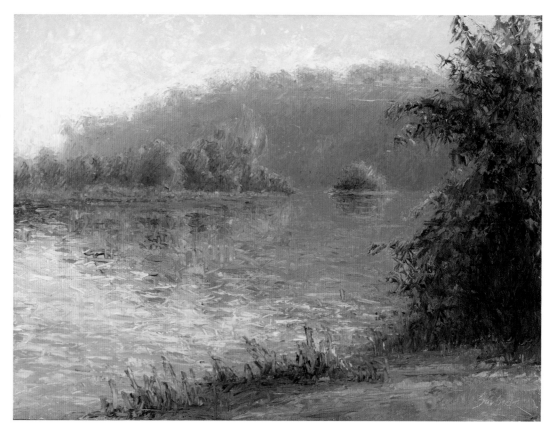

**The Bluffs,
Autumn Dusk,**
oil, 11 x 14 inches,
Susan Sarback,

As you can see, the early evening light creates a totally different light key. Those orange bluffs are now blue. The backlighting of the setting sun created a yellow edge to the mid ground trees and the sky reflection in the water has a golden glow.

Comparing Light Keys

It may help to describe in some detail two of the obvious pairings: sunny vs cloudy and sunrise vs. midday. Sunny vs cloudy is the easiest distinction to make, and sunrise vs. midday is one of the most obvious distinctions within the same day. Keep in mind that these examples are generalizations. They are not formulas. We must each finally rely on our own vision.

SUNNY VS. CLOUDY

A sunny day has clear distinctions of light and shadow; a cloudy day has less obvious distinctions. An apple in full sun will show a definite difference between the sunlit side and the shadow side, whereas on a cloudy day, the light will fade softly into shadow. Colors in sunlight tend to be warmer than those under clouds. The sunlit side of the apple will be warmer on a sunny day than on a cloudy one. This is not to say that warm colors are not present on a cloudy day. They certainly are, but on a cloudy day the light key itself is cooler.

SUNNY-DAY SUNRISE VS. AFTERNOON

Dawn is easily distinguished from afternoon. As the sun rises in the sky, it loses its fiery glow, usually becoming paler in color and shedding a more brilliant light. Generally speaking, the light key of sunrise is warmer than that of afternoon, though both are on the warm side of the spectrum.

The light keys change more subtly between sunrise and afternoon than between sunny and cloudy days, but this change is more obvious than many of the other light-key differences (i.e., late morning to early afternoon, rainy day and cloudy day, rainy summer day and rainy autumn day). With patience and experience, you will learn to see more and more of these distinctions.

Natural Light vs. Artificial Light

The light key of a painting will be influenced by the source of light. Natural sunlight has qualities that aren't duplicated by artificial light because sunlight has a balance of the full spectrum of colors. For this reason, most students study color outdoors, although this may not be convenient for everyone, especially in bad weather.

If you do paint indoors under artificial light, it is helpful to know the particular qualities of your light source. The four common types of artificial lighting are incandescent, fluorescent, full-spectrum and halogen.

Incandescent lighting tends to shift colors to the warm side, while fluorescent lighting generally makes colors appear cooler. Also, the range of color is reduced with these types of lighting, obliterating some of the more subtle color variations.

Full-spectrum light offers a wider range of color than incandescent or fluorescent. Full-spectrum light comes in varying forms, some of which shift the spectrum in the warmer direction, and others that shift it to the cooler side. I prefer halogen lighting for painting indoors. I believe it contains the widest range of color, and is closest to the effects of sunlight.

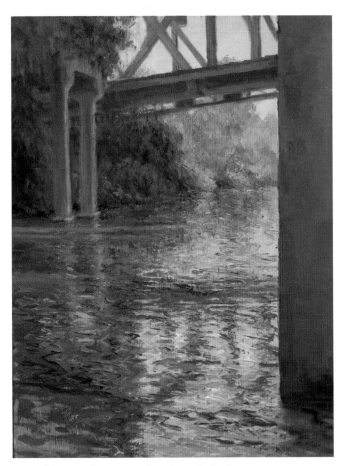

From the Pier, oil, 12 x 16 inches, Susan Sarback.

This was painted in Northern California on a hot Spring day. The humidity was low so the colors are bright and crisp.

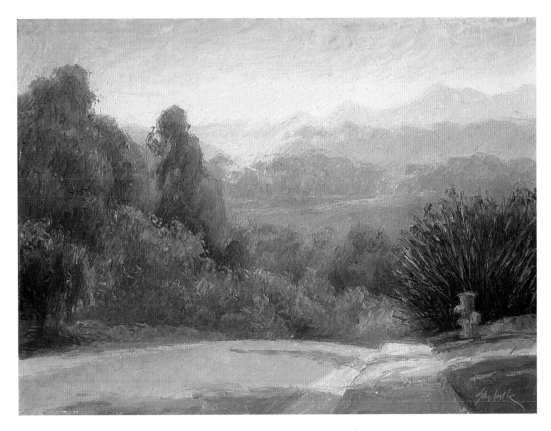

San Diego Vista, oil, 12 x 16 inches, Susan Sarback

This early morning painting in Southern California shows the coastal haze that often is seen. Note the layers of colors that create distance. In the foreground, the light color of the road is warm and dull and the cast shadows change color from cement to asphalt.

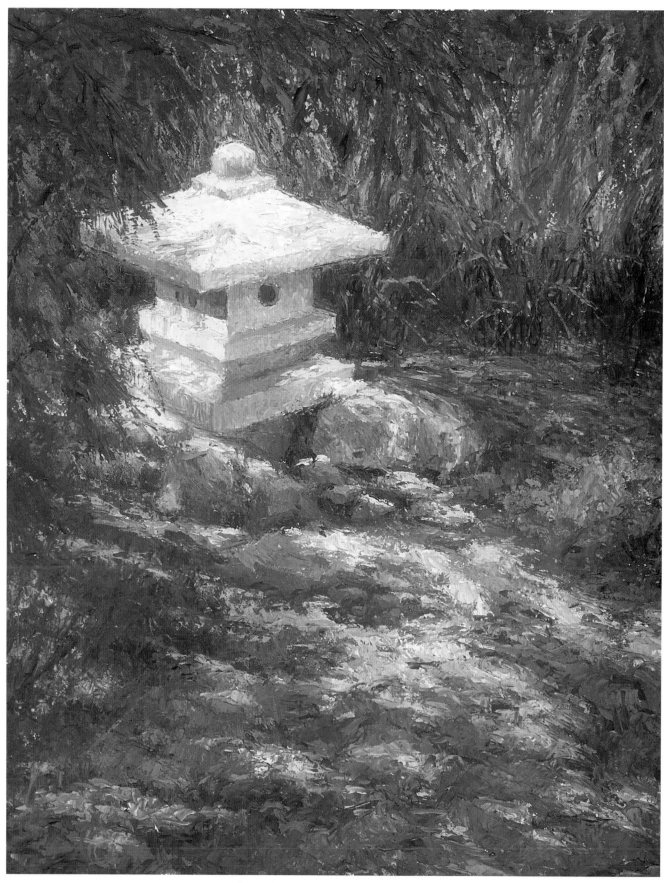

Temple Garden, oil, 16 x 20 inches by Susan Sarback.

Keys to Masterful Painting in Full Color

If you want to be original—go back to the origin of things.
The best art the world has ever had is but the impress left by men
who have thought less of making great art than of living fully
and completely with all their faculties in the enjoyment of full play.
From these the result is inevitable. The object is not to make art but
to be in the wonderful state which makes art believable. It is living life.
Those who live their lives will leave the stuff that is really art.

ROBERT HENRI

You can't add a thing by thinking—what you are will come out.

CHARLES HAWTHORNE

In the style of the great Venetian school, the idiosyncrasies of Titian,
Tintoretto, Giorgione and Veronese are distinctively
each individual's so that each canvas or any section of it
can be recognized as the particular artist's work.
They are similar only in that they express a universal concept of ideas.
Their individuality crept in unknowingly as they strove to paint truth.

HENRY HENSCHE

I invent nothing. I rediscover.

AUGUSTE RODIN

Full-color seeing is, in a very real sense, a language of light and color. Receptivity is the key to becoming fluent. As with speaking a foreign language, until some proficiency is gained, it is difficult to convey one's innermost thoughts and feelings. Once painters learn it, they can use this language of light and color to express themselves in any painting style, subject matter or medium.

The painter's individuality shines through his or her work in much the same way that each person's handwriting is unique. The artist or writer is focused on the image or the message, yet the results always reflect something of the character and nature of the creator. You can't hide your individuality, even if you try—your work always reveals something of who you are.

When I studied at the Cape School, I was fascinated when I compared the results of several painters who painted the same scene. Even when a whole group of advanced painters painted a color study of the exact same still life, it was usually easy to pick out the work of individuals. Many qualities were revealing: composition, thickness or thinness of paint application, size and character of the paint strokes, degree of detail, looseness or carefulness of the rendering, color tendencies and so forth. A painting always carries the stamp of the person who made it.

Three Keys to Masterful Painting

In twenty years of teaching all levels of painters, I've been fascinated with artists' different approaches to their work. One may be passionate, using bold strokes and thick layers of paint. The person next to them may use paint sparingly and focus on the tiniest detail. Both painters run into road-blocks, and here's why: they don't apply three key elements used by the great masters.

These three keys are thinking, feeling, and seeing. Generally, each artist leans on one more than another. But the best artists develop all three.

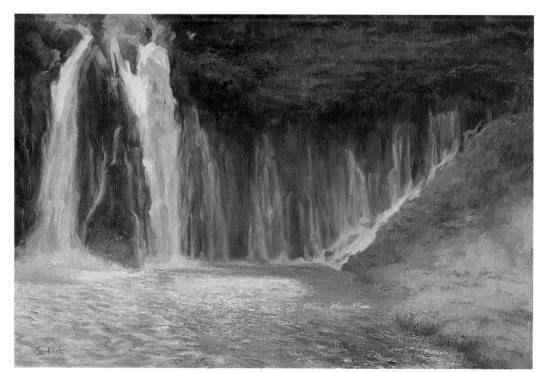

Falling Free, oil, 20 x 30 inches, Susan Sarback.

Painting is like juggling many things at the same time. This painting required seeing the color relationships and the light key, feeling the falling water, the churning water, and the heat of the day, and thinking about how to compose this to create a sense of space and movement.

CLEAR THINKING—TECHNICAL KNOWLEDGE AND SKILLS

Many believe that passion is all that's needed to produce great artwork. Some believe that thinking hinders feeling. But without thinking it's unlikely you'll achieve strong composition, radiant color, and accurate values. Clear thinking requires well-developed technical skills—an essential element to good painting. Look at the work of Vermeer and Michelangelo. Both artists had formal drawing skills and excellent technique. These basic skills make a painting read well—the road recedes in the distance, the building's perspective is correct, the apple sits on the plate and is well formed.

But thinking alone doesn't make a painting strong. A person who has developed clear thinking, knowledge and skills, but not the other two keys—seeing and feeling—may find that their paintings appear mechanical, less human.

The goal for that artist may be to develop the feeling side of their painting—loosen up.

Anticipation, soft pastel, 10 x 14 inches, Marianne Post.

This painting has a good balance of seeing, thinking and feeling. Notice the high degree of skill seen in this pastel. It reflects clear thinking with a strong composition and radiant color.

The Boats at Bodega Bay, detail, soft pastels, Irene Lester.

The technical skill of this artist is evident in the way this pastel shows atmosphere, space and the suggestion of trees and boats. Notice that even though the detail appears to be descriptive, the scene does not come forward, but recedes into the distance.

Poppy Field of LeVigne, oil, 16 x 20 inches, Rhonda Egan.

The suggested foreground flowers receding into the distance convey the image of a brightly colored poppy field. Without any precise detail, this artist has captured a joyous, rhythmic feeling on this summer day in France.

FEELING AND PASSIONATE EXPRESSION

Feeling is the human element. Without it, a painting can appear lifeless. A well thought out composition with beautiful drawing and color may appear technically accurate but lack a passion for life.

A strong feeling element is often reflected in the ability to edit and suggest, choose a subject, and apply paint—strokes, textures, looseness, and thickness. Van Gogh was a good example of a passionate painter.

Passion moves people. It stirs the heart, inspires growth and change, but without seeing and thinking, it creates problems. Painters who have developed feeling but never analyzed their work may do paintings that open the heart but don't create atmosphere, distance, and radiance.

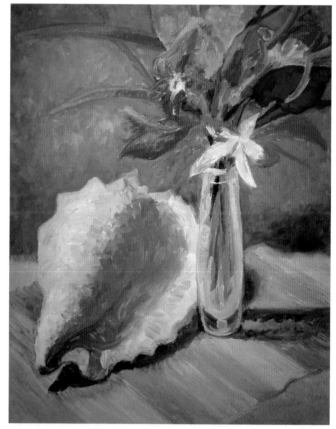

Color me Warm, oil, 16 x 20 inches, Paula Cameto.

Painted with loose brushstrokes, this colorful still life has the feeling of cozy happiness on a sunny day. Notice the full spectrum color both in the shell and the flowers.

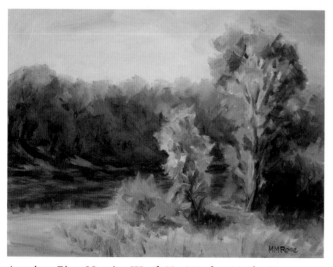

American River Morning III, oil, 11 x 14 inches, Marilyn Rose.

This painting has strong feeling reflected in the looseness and freedom of the brushwork. Painting quickly on location, the artist edited and suggested the grasses, trees, and the river.

SEEING WITH A REFINED EYE

Seeing is based on refined visual perception of values (light/dark), temperature (warm/cool), and chroma (bright/dull). If the relationships between these are accurate, the painting will radiate with light. Monet was a painter who developed his seeing faculty. His paintings are radiant and luminous.

Achieving radiance and luminosity comes from accurate seeing and painting. In full-color painting, "seeing" is the master key. It unlocks a richer world of beauty and truth—beyond imagination. To see with a refined eye we must be receptive, open, and relaxed, with a childlike sense of wonder.

The ideal is to evolve a dynamic balance of thinking, feeling, and seeing, based on your own individuality. Your strength as a painter is your uniqueness, developed. As you paint more, your skills develop and your uniqueness emerges. Painting is a process of unfolding who you are as an artist and person. These three keys help you create paintings that radiate with your unique expression of light and color.

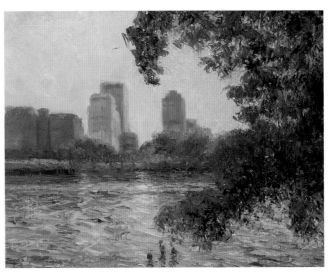

Downtown, Across the River, oil, 11 x 14 inches, Susan Sarback.

Refined visual perception does not necessarily require that a painting be labored over for a long time. A sense of freshness and aliveness can be achieved by seeing the colors and applying them in a loose, quick, painterly style. This painting was completed in about one and one-half hours.

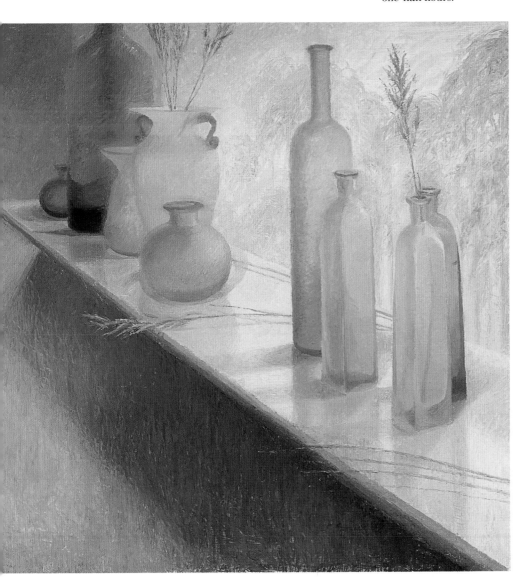

Nine Bottles and Wheat, oil, 30 x 30 inches, Susan Sarback.

Refined visual perception brings radiance and luminosity to any subject. The glass bottles are on a window sill, under a sky light, on a foggy day. Notice the color variations in each bottle. The full spectrum is present but the distinctions are nuanced and subtle in this type of weather condition.

Shibui—The Ultimate in Beauty

Art is a means of seeing deeper into nature, through interpretation instead of imitation. Some art seeks out the rare, palpable essence or quality of timeless beauty.

Such beauty has always preoccupied the Japanese culture. Over the last ten centuries, they have developed exacting standards of beauty and realized a deeper understanding of what comprises beauty. Frankly, they may have surpassed other cultures in this.

With their realization, the Japanese developed a set of values to analyze the various grades and facets of beauty. This set of values is called Shibui.

Shibui involves balance, measure, restraint, control, calmness, discipline, elegance, and strength used in a way that would seem to be easy and effortless. It shows the universal principles of beauty in action. Some call it "severe exquisiteness."

Let's look at Shibui's particular traits:

1. Simplicity
2. Implicitness—or meaningful depth, something rich with meaning
3. Humility—or not imposing oneself on the subject
4. Tranquility—or serenity, quiet, and calmness
5. Spontaneity—a sense of naturalness
6. Contact with the commonplace—seeing and creating beauty out of the common things in life
7. Imperfection—the naturalness of life that includes the awkward and homely in a complete, honest rendering of beauty.

How does Shibui influence painting, and why is this important to our study of light and color?

The Impressionists were greatly influenced by Japanese art. Many of them owned Japanese prints and studied Japanese aesthetic qualities. Over the years, this study greatly influenced the Impressionists' values and even their painting methods: In many cases their work took on a new refinement, and became simpler in style and subject. Their approach to seeing and painting reflected a new depth of perception about nature and light—which in turn opened the viewer's awareness about life.

Monet was a good example of an Impressionist painter greatly influenced by Japanese aesthetics. For years he had understood the great humility needed to paint nature and called himself a "hypersensitive receptor." To Monet, this receptivity was like meditation, and brought him a tranquility, serenity, quiet, and calmness—a oneness with life. Plein-air painting, Monet's strength, is outdoor painting in natural surroundings, and demands spontaneous, rapid responsiveness—the essence of Shibui at work.

Invoking another aspect of Shibui, many Impressionists chose common, everyday subjects—not romanticized images. Perfect rendering was not a consideration for them. They wanted to capture the essence and quality of light. Their paintings were not precisely accurate or photographic; they had many imperfections, as nature does.

A good number of Impressionists also worked with atmospheric perspective, instead of traditional Western perspective. This is another important Eastern spatial principle.

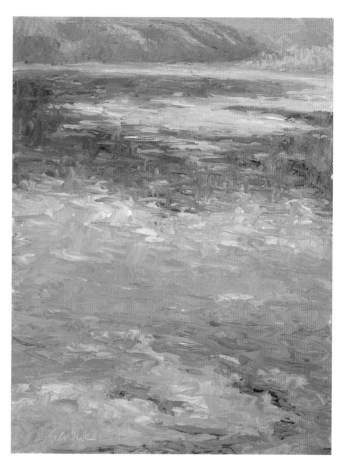

Pond, Quiet Morning, oil, 9 x 12 inches, Susan Sarback.

This quick plein air painting is almost abstract in nature. It captures a section of nature in motion. This simple tranquil scene describes little but suggests a lot. It captures the Shibui qualities of simplicity, serenity and spontaneity.

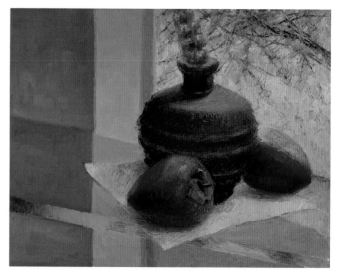

Cobalt and Persimmons, oil, 11 x 14 inches, Susan Sarback.

A vase and two persimmons on a windowsill is a simple common subject. With Shibui, the artist creates something special and beautiful out of common everyday things. This tranquil subject captures a quiet reflective mood on a winter morning.

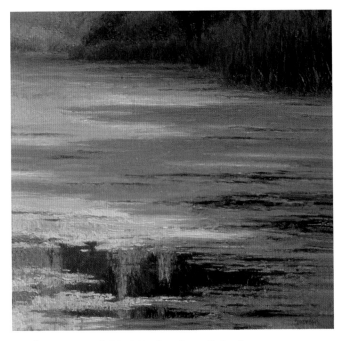

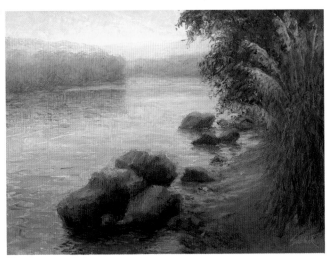

Dawn, Lake Natoma, oil, 11 x 14 inches, Susan Sarback.

On this hazy morning, the atmosphere created a soft tranquil feeling that is not simply pretty, but touches on an eternal quality of light. These colors are created with a mixture of spectral colors. Atmospheric perspective along with luminous color create the illusion of distance.

Pond, 8:00 a.m., oil, 24 x 24 inches, Susan Sarback.

This painting captures the essence of the "whole" by suggesting a fragment of the scene. Notice the simple rhythmic movement, seen in the light and shadow across the algae pond and in the sky and tree reflection in the clear water. This evokes a sense of mystery moving back into space and deep into the water.

SHIBUI—A REFINED PERCEPTION

Shibui goes far beyond mere prettiness and touches on eternal beauty. True beauty has elements that make us want to examine it, study it. This has nothing to do with taste; it has to do with universal, eternal principles of beauty. I've found that painting with the principles of Shibui creates a more profound, lasting quality in my work.

First, it's important to choose your subject carefully. The less dramatic subject may be much more powerful. Less is more. Unobtrusive subjects may be more interesting. As we paint them, our art becomes less self-conscious and has more presence, beckoning the viewer to look deeper, to search for hidden meaningfulness.

Shibui also helps the painter develop a delicate perception and learn to see the whole of a thing, instead of just a part. It encourages the unfinished statement which evokes the whole, i.e., a portion of a tree, waterfall, or mountain. A section of the scene may be more powerful than an elaborate rendition of the entire scene. Showing the whole scene may be too obvious. Shibui works with the power of suggestion and leaves more room for originality than does correctness and what is commonly called "good taste." Symmetry is often avoided in favor of a fragmentary glimpse which can convey a whole scene.

This incompleteness is a crucial characteristic of Shibui and Japanese art. It goes beyond realism and truly interprets, allowing a deeper understanding of the subject than mere outward form

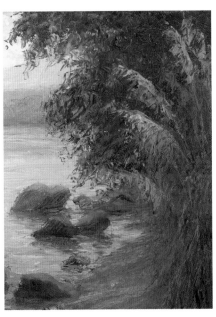

Dawn, Lake Natoma, detail.

Notice how this cropped image of the above painting creates a completely different feeling. This vertical image has a more active feeling than the horizontal painting. Since the water is now only one third of the composition, the movement of the trees blowing in the wind becomes dominant. In this case, a smaller section of the scene, a fragmentary glimpse, became more powerful than the entire scene—Shibui in action.

can convey. I've heard Japanese paintings described in this way, "This was done by the great Japanese master with a few deft lines or strokes of the brush, like a few well-chosen words as compared to flowery oratory." You can also see this in the rapid brushwork and brilliance of Impressionist painters like Claude Monet.

Shibui is about organic simplicity. This simplicity can produce richness and strength in your work. It is not mechanical perfection, but mastery and a sense of inner rightness.

This quality is what leads to exquisiteness in art.

Students painting outdoors, left to right: Carmel By The Sea, CA; a mountain lake in North Carolina; and overlooking a Napa Valley, CA vineyard.

Questions and Answers About Full-Color Seeing

Q: How can I improve my color vision?

Susan: Practice the seeing exercises frequently. Make them a habit. Practice seeing full color even when not painting. You'll find your vision will change and expand as you do this. Paint still life as often as possible and choose objects with a variety of colors. Regular classes and workshops can refresh your learning.

Q: I love to paint landscapes. Why do I have to paint still life?

Susan: Still life is the foundation for painting anything else. I continue to paint still lifes regularly. All the problems that exist with still life also exist with landscape painting—a combination of forms and colors, creating volume with color, translucency, transparency, dark dull objects as well as bright objects, reflective surfaces, and a combination of soft forms with solid objects. Landscapes have the additional challenges of distance and a variety of atmospheric conditions.

Q: How can I use this approach in other mediums, such as watercolor or colored pencil?

Susan: First, study with an opaque medium such as oils or soft pastels. Then, after you get enough experience and understanding of this approach, transfer it to other mediums. For example, do a pastel study then do the same painting in watercolor—after you figure out the correct color relationships with the pastels.

Q: What's the best way to learn how to paint full color?

Susan: Study the basics of this approach, and know the four stages well. Practice Stage One and Two often and don't worry about finishing a painting. Paint often. Study books and videos, and when you can, take full-color painting classes and workshops. It's important to have plenty of instruction when you're just beginning, so that your learning is streamlined.

Q: Can I learn this method even if I'm not talented?

Susan: Yes. Talent is just a jump-start. The best painters usually study for years and take the time to develop their skills. There may be certain aspects of painting that are natural for some, but may not be natural for others, such as fluidity, focused detail, composition, rhythm and color. A talented person may have several of these naturally but they usually have to work to develop other aspects, just like anyone else. I've seen many people become very good artists though they had little natural talent. What they did have was great desire, commitment to learn the skills needed, and persistence to practice regularly.

Q: How can I keep the feeling of freshness and aliveness in my paintings?

Susan: Quick studies are almost always fresh and alive. Henry Hensche once said that the mark of a good painter is to be able to retain the freshness of a painting no matter how long you work on the painting. It's difficult to keep the freshness because we tend to want to perfect the painting the longer we work on it. Try to keep the initial feeling of the subject with you throughout the painting. Paint looser, use more paint, paint quicker, paint with a variety of edges, stay away from details, and try to "feel" the subject, i.e., the wind blowing in the trees.

Q: How can I learn to paint a landscape that's primarily green?

Susan: When painting grasses, trees, and bushes, the color green often dominates. One general rule to follow is to stay away from using green for as long as possible. Begin the first stages with warm colors in the sunlit areas i.e., yellow, orange, red, or pink. Use cool colors (except green) in the shadows, such as blue, purple, or magenta. By doing this you have a foundation of color that is not the local color of green. If everything starts with green it will simply end up to be a painting of local color or shades of green.

Q: What are the keys to painting trees that are close up and trees that are ten miles away?

Susan: Green generally comes forward and can dominate. Observe the differences between green areas—foreground and distance—to see how the colors vary. Trees in the distance will be cooler, lighter, duller, have less contrast, and no sharp edges. Trees in the foreground will usually have more contrast of value and temperature, the colors may be brighter, the texture is greater. Make sure that the foreground trees have a minimum of three colors and values to show three different planes.

Q: Does full-color painting always appear to be bright?

Susan: The beginner full-color painter may paint everything brighter than it is. That's because the bright colors are easier to see and to paint—they're obvious. There are about twenty bright colors and thousands of dull or somber colors. A refined eye and the ability to see and paint the differences between these dull colors are more advanced skills. A full-color painting should not look overly bright but should reflect the range of spectral colors and the quality of light. Usually only a few areas of the painting will be bright. The rest will be refined subtle colors made by mixing spectral colors.

Painting Workshops and Classes at The School of Light & Color

About the School of Light & Color

The School of Light and Color is located in the picturesque village of Fair Oaks, California, about twenty miles east of Sacramento. The building houses a roomy studio as well as the Chroma Gallery, which features over twenty artists.

The School of Light and Color offers in-depth art instruction for students of all levels.

Staff instructors give classes and workshops in drawing, pastel, watercolor, and classes for youth. The staff instructors, whose work can be seen in this book, include Rhonda Egan, Irene Lester, Paula Cameto, Marianne Post and Marilyn Rose.

Susan Sarback offers her well-known weekly light and color classes, including an outdoor landscape class, offered seasonally, as well as several indoor color classes, offered thoughout the year.

During the year Susan Sarback also teaches many comprehensive workshops, lasting from 3 to 5 days each, at the School of Light and Color in Fair Oaks, as well as at various other locations around the country. She offers:

Color Intensive Workshops: These in-depth workshops focus on specific seeing and painting techniques based on the light and color approach used by the Impressionists. Through painting a variety of still life subjects, the student learns the foundation needed to paint any subject—landscape, portrait, etc. A slide presentation and painting demonstrations are included in each workshop.

Plein-Air Landscape Workshops: These popular outdoor painting workshops focus on capturing the different qualities of light as seen in various weather conditions. Students learn composition, color, choosing a subject, and skills to rapidly capture the outdoor atmosphere. (The landscape workshop is for those with a basic knowledge of drawing and values or for those who have previously taken a Color Intensive Workshop.)

For more information, please contact
The School of Light & Color
10030 Fair Oaks Blvd., Fair Oaks, CA 95628
(916) 966-7517
sarback@lightandcolor.com www.lightandcolor.com

Index

Learn to paint gorgeous oils and pastels with these other fine North Light Books!

The perfect book for any artist with limited space to paint, limited funds for supplies, or physical restrictions, *Big Art, Small Canvas* gives readers the techniques they need to create tiny masterpieces quickly and affordably.

With basic instruction for beginner or intermediate painters, the book focuses on capturing landscapes and still lifes in tiny oils, leading to art that can be hung in a variety of places, and making it easier for aspiring artists to get a foot in the door with galleries.

ISBN-13: 978-1-58180-777-6; ISBN-10: 1-58180-777-5; Paperback, 144 pages, #33448

No other current book focuses entirely on representing weather in landscape painting. From the haze of summer to the snow of a blizzard, *Painting the Elements* provides all the step-by-step instructions you need to portray a wide variety of climates and conditions. Bring the most dramatic landscapes to life in oil, acrylic, and watercolor with over 25 projects that showcase the work of North Light Books' bestselling authors!

ISBN-13: 978-1-58180-887-2; ISBN-10: 1-58180-887-9; Paperback, 192 pages, #Z0275

No two artists are alike and this book helps artists discover their own individual style. *Finding Your Visual Voice* directs artists to recognize their visual preferences and focus their painting efforts with insights from accomplished painters, 8 step-by-step demonstrations, and many examples. A selection of paintings with questions and prompts at the end of each chapter directs the reader to the style of art they want to create.

Artists will learn information about the painting process, determine exactly what they want to express through their art, and identify the specific skills needed to accomplish their artistic goals.

ISBN-13: 978-1-58180-807-0; ISBN-10: 1-58180-807-0; Hardcover, 176 pages, #33486

The Artist's Muse will appeal to any artist who's struggled with creative block or who's looking for new and exciting ways to grow their work.

This unique book and card game kit is packed with creative prompts and idea sparkers. By mixing and matching the cards, and following the visual examples in the book, readers will find a realm of creative possibilities at their fingertips, leading to a more personal and confident artistic style.

ISBN-13: 978-1-58180-875-9; ISBN-10: 1-58180-875-5; Paperback, 96 pages, #Z0345

THESE BOOKS AND OTHER FINE NORTH LIGHT TITLES ARE AVAILABLE AT YOUR LOCAL FINE ART RETAILER OR BOOKSTORE OR FROM ONLINE SUPPLIERS.